Collins
Artist's
Little Book
of Colour

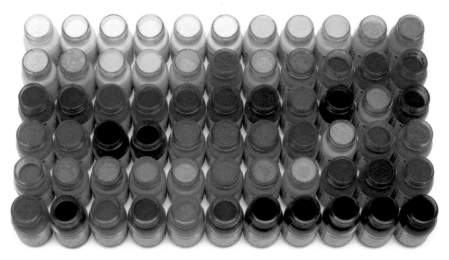

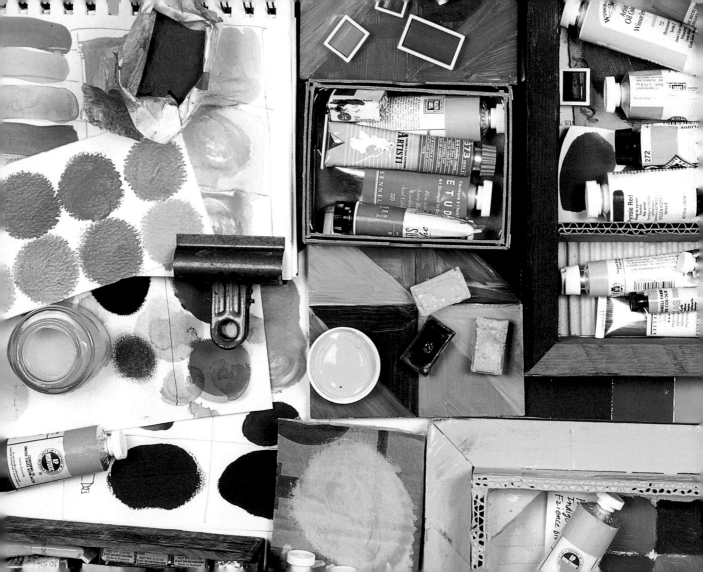

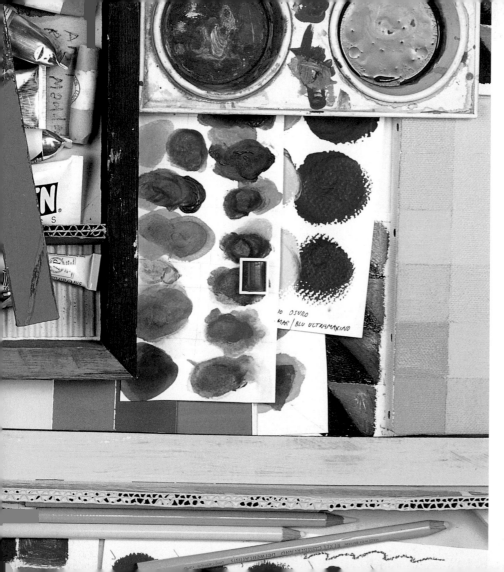

Collins
Artist's
Little Book
of Colour

Simon Jennings

Collins

First published in 2007
by Collins,
an imprint of
HarperCollins Publishers
77-85 Fulham Palace Road
London W6 8JB

The Collins website address is
www.collins.co.uk

11 10 09 08 07
5 4 3 2 1

Based on material from
Collins Artist's Colour Manual

Conceived, edited and
designed at Auburn
Studio, Bristol, UK

Research, Text
and Design:
Simon Jennings

Editorial Director:
Cathy Gosling

Text Editor:
Geraldine Christy

Technical Consultant:
Emma Pearce
Winsor & Newton

Art Educational
Consultant: Carolynn
Cooke

Studio Photography
and Jacket Photography:
Ben Jennings

Colour Charts
and Research:
Chris Perry
Rose Jennings

ISBN 978 0 00 726636 4

Colour origination by
Colourscan, Singapore

Printed and bound by
Printing Express,
Hong Kong

Collins
Artist's
Little Book
of Colour

Contents

Introduction 7
Artists' pigments 8
Colour by colour 11
Blue 12
Turquoise 20
Violet 22
Red 24
Orange 32
Yellow 36
Yellow Ochre 44
Green 46
Green Earth 54
Brown 56
Black 64
Grey 72
White 75
Colour Index 79
Guide to suppliers 123
Pigment standards 124
Colour terminology 125
Index 126
Acknowledgements 128

Introduction

The subject of colour is so vast and the ranges of pigments and materials available to the artist so wide, variable and subtle, it is inevitable that the best means of finding out how particular colours really look and handle is by actually using them.

In this book there is a great deal of information about colour and its value to the artist. Hundreds of colours are mentioned and shown in the various media in numerous combinations, mixtures and applications. Most artists will admit that the only effective way to knowledge and confidence is to experiment with the actual colours and different media yourself. It is hoped that this book can provide a springboard into the world of colour for the artist.

Unfortunately, there is one obvious drawback to it. This is that when it comes to the subtlety of reproducing colour all of the colours shown here are printed, not painted. They are not the actual colours at all, but are reproduced by the four-colour printing process using only four ink colours. Modern printing technology and the skills of graphic reproduction have brought us very close to the reality of seeing real, pure pigment colour on the printed page.

The four-colour process
Every colour you see in this book is printed by using the four-colour process. Every hue, tint and shade is made up of a combination of only four colours. These are: cyan – a bright, greenish blue; magenta – a bluish-shade red; yellow – a middle yellow, neither reddish nor greenish; and black. White is provided by the white of the paper on which these four colours are printed. In printing terms these colours are known as the process colours and are designated as CMYK ('smike') – C for cyan, M for magenta, Y for yellow and K for black.

PROCESS CYAN
120

PROCESS MAGENTA
412

PROCESS YELLOW
675

PROCESS BLACK
040

Today's artists are lucky in being constantly provided with pigments that are more permanent and offer an ever-widening choice of handling properties. In less than 200 years the finest quality ranges have improved from around 30 per cent permanent to 99–100 per cent, as well as providing two or three times the number of colours. Although many early pigments are now replaced by more reliable ones, many are not. Incurable romantics may find it pleasing that the first pigments available to man remain some of the finest available to the artist.

An average palette

An average palette today of only twelve colours contains a selection of pigments from every historical era as well as every pigment type. Broadly defined, pigments belong to one of three types.

Earth colours
Ochres, siennas, umbers and Mars colours.
Traditional colours
Cobalts, cadmiums, titanium and ultramarines, for example.
Modern colours
Phthalocyanines, quinacridones, perylenes and pyrroles, for example.

Categories of pigment
Chemically, pigments are categorized by whether they contain carbon or not. This results in a more technical, but more accurate, definition of possible types.

Inorganic pigments
Earth, mineral (for example, cinnabar), synthetic (for example, cobalt).
Natural organic pigments
Rose Madder is an example in this category.
Synthetic organic pigments
The quinacridone colours fall into this category.

The first colours
More than 15,000 years ago cavemen began to use colour to decorate cave walls. These were earth pigments, yellow earth (Ochre), red earth (Ochre) and white chalk. In addition they used carbon black (Lamp Black) by collecting the soot from burning animal fats. These colours were all that were needed to produce the sensitive and exquisite drawings and stencils that we are still able to see today.

Can it get any better?

By the 1990s more pigment types of synthetic organic origin were appearing. Perylenes, pyrroles and new arylides (for example, Hansa yellows) have come into use. In some cases new hues are available, further extending the possibilities in watercolour or filling a perfect gap in portraiture, or providing even greater transparency for mixing or glazing. In other cases some good lightfast pigments were replaced by pigments that were even more lightfast. So we replace colours that last for a few hundred years with ones that last many hundreds of years! Today's artists are certainly fortunate to be living and painting in the twenty-first century.

Thanks to the automobile!

The car permanently has to endure the elements and pigments used for automobiles must withstand snowbound or desert conditions. Artists have everything to be thankful for that such lightfast pigments had to be developed. Without the car we would not have the reds, yellows and purples that we enjoy today.

Do not take colour for granted!

With just one colour there are many factors that affect what you see on the paper or canvas; these include thickness of colour, medium used, surface used, strength of pigment, use in mixtures, juxtaposition, transparency, colour bias and more. This variation is multiplied by the number of colours available. In a well-spaced artists' range there may be as many as 80 single pigment colours. Combine this with individual artists and an infinite array of results is an understatement!

In a realm all its own... *Cadillac*

9

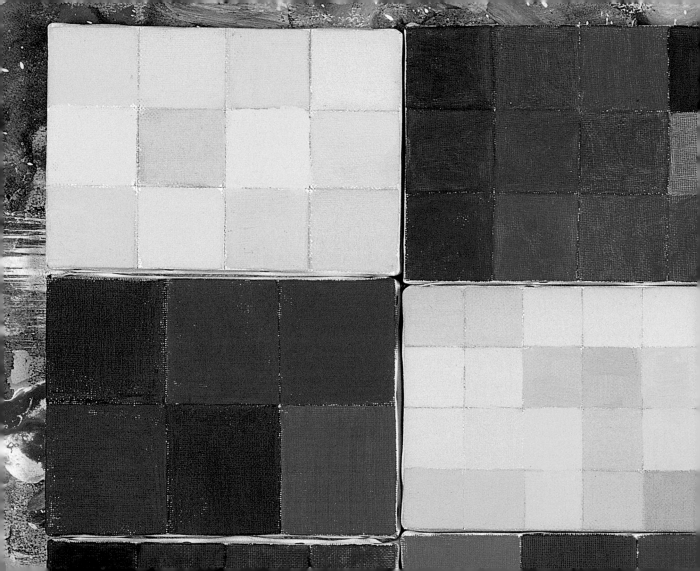

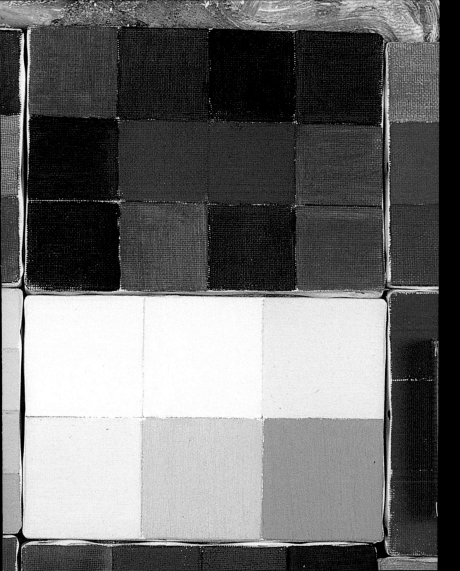

Colour
by colour

On the following pages we explore many of the most popular 'core' colours that are currently available to artists. We learn about the history, composition and attributes of these colours, and how they have been developed and refined into the artists' pigments we are familiar with today.

An essential colour

Blue is overwhelmingly present in our lives for it is the colour of the sky, providing an ever-changing backdrop that is echoed and reflected in the sea, rivers and lakes. In relation to the spectrum and the colour wheel, the term 'blue' applies to all those colours that are between violet and turquoise. Blue retains its distinct character more clearly than the two other primary colours, red and yellow, when white or black is added.

From space our planet looks blue. Described by Kandinsky as the 'typical heavenly colour', blue carries a sense of the spiritual. It suggests calmness and serenity in its lighter tones and mystery as it approaches black. In some situations it may convey sadness and melancholy, hence to have 'the blues'. Used in mid-bright clarity it is an ethereal, expansive colour, while deeper, richer blues have velvety depths that evoke opulence and mystique.

Respect for blue increased with the discovery of the extraction of Ultramarine from lapis lazuli during the Middle Ages. It was not until the sixteenth century, however, that blue was properly recognized as an essential basic and distinct colour.

Early Blues
Though blue was known and used by the ancient civilizations, it was considered a lesser colour. The Greeks had no separate word for blue, instead classifying individual blue colours with terms such as *kuanos*, from which we derive the word 'cyan'. Blue as an overall term was categorized as a black or dark.

Frit

The Ancient Egyptians used several shades of blue, among them a colour that was synthesized from copper silicates and calcium oxide. These ingredients were fired with sand to produce a ceramic glaze and a glass-like substance known as 'frit'. When ground this produced a soft blue pigment powder, a colour later referred to by the Romans as Egyptian Blue or Alexandrian Blue.

Azurite

Another colour found in Egyptian wall paintings was derived from azurite, a copper carbonate mineral related to malachite. This gave a deep blue that veered towards green. Azurite was also used by the Greeks, who obtained its source mineral from Armenia, referring to it as 'Armenian stone'. It was still in use in the fifteenth century by Renaissance artists who tended to use azurite as an underpainting for the more costly Ultramarine. The colour was also known as *azzurro della magna* or sometimes as Mountain Blue.

Woad

Woad had been used in northern Europe since the time of the Ancient Britons, who dyed their faces blue in an effort to strike fear into the invading army of Julius Caesar in 55BC. It was obtained from the leaves of the *Isatis tinctoria* shrub and was a colour similar to indigo. Artist monks used woad for blue to illuminate the *Book of Kells* in the eighth century.

'In music a light blue is like a flute, a darker blue a 'cello; a still darker a thunderous double bass; and the darkest blue of all – an organ.'
Wassily Kandinsky (1866–1944)

What is blue?

'Of the colour between green and violet in the spectrum, coloured like the sky or deep sea (also of things much paler, darker, etc., as smoke, distant hills, moonlight, bruise; and qualified by or qualifying other colours ...).'
Oxford English Dictionary

Alexandrian Blue
Antwerp Blue
Berlin Blue
Blue Ashes
Blue Bice
Blue Verditer
Bremen Blue
Delft Blue
Egyptian Blue
Indian Blue
Leyden Blue
Mountain Blue
Paris Blue
Pozzuoli Blue
Sky Blue
Smalt
Smalt Blue
Thénard's Blue
Vestorian Blue

Naming blues

Many old names have been superseded, but you may see historical references to the above.

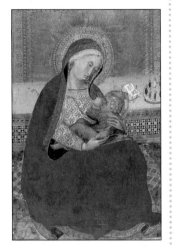

The cost of Ultramarine
Artists tended to use the colour for the most important areas in a painting, such as the Virgin Mary's robe.

Blue from beyond the sea

While the Greeks and, particularly, the Romans had brought colours and dyes from the East, the Middle Ages saw flourishing trade routes re-established. Two colours from the Orient were especially important – Ultramarine Blue and Indigo.

Ultramarine

The name Ultramarine – meaning 'from beyond the sea' – gives some indication of the colour's exotic standing. This pigment, rich royal-to-purple blue in colour and more expensive than gold, was obtained from a semi-precious gemstone called lapis lazuli ('blue stone'). Still rare, lapis lazuli is chiefly found in Afghanistan.

The high cost was reflected in its use, and master painters of the Renaissance were instructed to use the colour to denote their patron's status and wealth. These artists were even contractually required not to economize on Ultramarine by substituting a cheaper blue.

Indigo

Indigo, as its name implies, was imported from India. Fermented from the leaves of the *Indigofera tinctorum* plant, it produced a deep purple-blue dye that was thirty times stronger than woad. For painters it was available in the form of a lake

pigment and was sometimes used by Renaissance artists as an underpainting to give depth and to warm the effect.

Indigo dye

In the nineteenth century under the Raj the British turned Indigo production in India into a major industry. As a textile dye the colour was used all over the world for uniforms. Though all blues are fugitive, Indigo is particularly prone to fading. It is still used on a large commercial scale for work clothes such as overalls, but the colour has been synthesized since the early twentieth century.

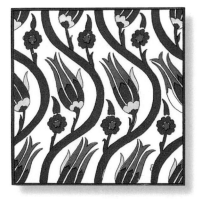

Iznik tile

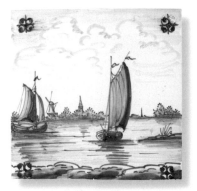

Delftware tile

Smalt

Smalt was one of the first useful blues that had cobalt as an ingredient. A deep blue colour, Smalt was used widely from the sixteenth to the eighteenth century and superseded azurite. It was ground from a glass frit produced from cobalt oxide and J. M. W. Turner (1775–1850) is said to have used great quantities of 'smalts of various intensities'.

Iznik tiles

During the sixteenth century the potters of Iznik in Turkey created beautiful glazed tiles based on geometric and floral motifs, (see above left). Cobalt blue was used first as a single colour, but later colours such as turquoise, copper greens and a manganese red-purple were incorporated into the designs.

Leyden Blue

A type of cobalt blue called Leyden Blue was used as the glaze for the Dutch seventeenth-century earthenware that became known as Delftware (see below left). In their turn the Dutch were imitating the Ming Blue (also cobalt oxide) and white porcelain from China.

How to make an excellent Ultramarine Blue
'Take lapis lazuli and grind it fine on a porphyry stone. Then make a mass or paste of the following ingredients: for a pound of lapis, 6 ounces of Greek pitch, two of mastic, one of spike or linseed oil, and half an ounce of turpentine; bring it all to boil in a pot until almost melted, then filter and gather the product in cold water. Stir and mix it well with the powdered lapis lazuli and let sit for a week or so. The longer it rests, the better and finer the blue will be.

Libri Colorum
(The Book of Colours)
compiled by Jean Lebègue
(Fifteenth century)

Pigment use

The blue pigments most frequently used by modern manufacturers are PB15 Copper phthalocyanine, PB73 Cobalt silicate and PB27 Ferric ferrocyanide. PB15 is an ingredient in Indigo, Manganese Blue (Hue), Neutral Tint, Payne's Grey and Mauve, as well as the colours named Phthalo. PB73 is used as a single pigment in Cobalt Blue.

Blue pigments
PB15 Copper phthalocyanine
PB27 Ferric ferrocyanide
PB28 Cobalt aluminium oxide
PB29 Complex sodium aluminium silicate
PB35 Cobalt tin oxide
PB36 Cobalt chromium oxide
PB60 Indanthrone
PB73 Cobalt silicate

Chemical blues

Chemical experiments and advances in industrial technology in the nineteenth century saw the discovery of new ways of synthesizing blues that were the forerunners of colours used by artists today. Many of the core modern blues that artists use have familar names – such as Prussian Blue, Cobalt Blue, French Ultramarine and Cerulean Blue.

There are also several new blues such as Phthalo, Monastral and Indanthrene Blue. Manufacturers have developed their own colours and variations of them. With no historical tradition to these colours, they sometimes bear the maker's name or a descriptive name. Check on the manufacturers' charts for accurate chemical descriptions.

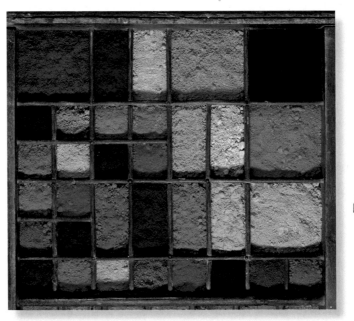

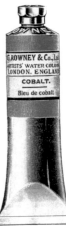

Prussian Blue

In 1704 Diesbach, a paint maker in the Prussian city of Berlin, added some impure potash containing animal oil into a cochineal lake he was making. The result was a chemical mix of ferric ferrocyanide and its colour was a deep, slightly greenish blue. A powerful, staining colour, Prussian Blue was fairly inexpensive to produce for use in dyeing textiles and as artists' colour. Other chemists in Europe were soon making their own versions. Prussian Blue is also known as Berlin Blue or Paris Blue. Antwerp Blue is a lighter version.

Cobalt Blue

The first synthesized Cobalt Blue was created in 1802 by a French scientist called Thénard; thus the colour was also known as Thénard's Blue. Its chemical composition was cobalt aluminate and it took over from Smalt. Cobalt Blue is a clean-looking blue that is neither warm nor cool and is available in shades from light to deep. Cobalt is also used to describe other colours derived from the metal, including violet and green.

Cerulean Blue

Named from *caeruleus* (Latin for 'blue'), this colour was discovered in 1802 by Höpfner, a German scientist, who produced it through heating cobalt and tin oxides. In 1870 it became an artists' colour when the English paint maker George Rowney marketed it as Coeruleum. It is a bright, greenish blue, particularly suited to painting watercolour skies.

French Ultramarine

Since Ultramarine was sourced from the rare lapis lazuli, it was prohibitively expensive. In 1824 the French Société d'Encouragement pour l'Industrie Nationale offered a prize of 6000 francs to any chemist who could discover how to manufacture an artificial Ultramarine. Four years later the French colour maker J.-B. Guimet came up with a winning synthetic recipe. Heating and washing processes resulted in an ultramarine colour that could be changed slightly by simply adapting the ingredient amounts. The colour became known as French Ultramarine, reflecting its provenance. Its cheapness ensured that it became a core colour for all artists.

The quest for blue
Since the accidental discovery of Prussian Blue in the early eighteenth century advances in technology have enabled the production of many new blues.

Basic blues
Many manufacturers offer basic mixing blues – ones that are recommended as good mixers for creating secondary colours. Among these you will often see Cyan Blue and/or Primary Blue. Cyan is traditionally a highly saturated green-blue that is the complementary of magenta. Cyan Blue and magenta, along with yellow, form a set of primary colours that are well known within the printing industry. The word 'cyan' is from the Greek *kuanos*, meaning 'dark blue'.

Modern blues

The twentieth century saw new synthetic chemical pigments and dyes that mimicked natural colours. These colours have considerably expanded the choice available to artists.

Phthalo Blue

This powerful colour is made from copper phthalocyanine, first synthesized in the early 1930s. As a deep, intense blue (it is sometimes named Intense Blue), it has replaced Prussian Blue to a great extent. Phthalocyanine provides a variety of blue shades that are mostly slightly greenish, but sometimes have a reddish tinge – for instance, Winsor Blue (Green Shade) and Winsor Blue (Red Shade). Other blues with phthalocyanine as their base are Hortensia Blue, Monastral Blue, Monestial Blue, Old Holland Blue, Rembrandt Blue and Thalo Blue.

Indanthrene Blue

This violet blue, similar to Indigo, was developed in 1901.

Some manufacturers market this colour instead of Prussian Blue and it creates good dark colours when mixed with umbers. Indanthrene Blue is more lightfast than the phthalocyanine blues, especially when used in tints. It is also called Indanthrone Blue.

Manganese Blue

This colour, developed in the early twentieth century, was made from barium manganate. Described as having 'an ice-blue undertone' it was a bright greenish blue, similar to Cerulean, but weaker in tinting power. Unfortunately, the pigment is now unavailable.

Core blues
The most common blues are Phthalocyanine (top right), Cyan or Primary (bottom right), Cerulean (top left), Ultramarine and Cobalt (bottom left). The pigment contents are usually the same, but note how hues vary from one maker to another depending on the formulation and the medium. The differences in colour can be considerable.

Homage to blue
French artist Yves Klein (1928–62) produced vivid single-hue paintings in the 1950s. In his desire to celebrate the full intensity of pigment he developed a new Ultramarine, patenting it as International Klein Blue (IKB). Suspending pure pigment in clear resin allowed the particles of colour to be displayed with startling vibrancy. IKB became Klein's trademark colour.

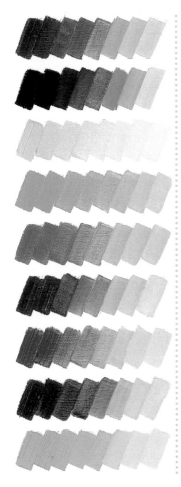

Between blue and green

The colour turquoise replicates the hue of the same-named semi-precious stone. Europeans gave the mineral its name in the thirteenth century because they imported turquoise through Turkey, though its source was probably Persia. Turquoise was also found in the American continent, where the Navajo, Zuni and Hopi Indians crafted artefacts and jewellery, working turquoise with silver.

Between the two

In ancient Mexico the Aztecs used turquoise mosaics to decorate sculptures and precious objects, combining the stone with jade. This juxtaposition of the two minerals perhaps led naturally to the use of one word to mean both blue and green. From the artist's point of view this is apt, for turquoise sits between these two colours in the spectrum, though it is not named as a separate hue.

Turquoise pigments

Natural turquoise varies in colour from a bright greenish blue to a pale bluish green. Its components are hydrated aluminium and copper phosphate. A pale turquoise green ceramic glaze can be produced from roasting aluminium, chromium and cobalt oxides.

There is no single synthetic organic turquoise. Artists can simply mix turquoise from blue and green pigments, thus controlling the precise colour of the turquoise required. There are also many prepared artists' colours that now bear the name turquoise. Manufacturers create turquoise by combining blue (PB) and green (PG) pigment ingredients. These are mainly based on phthalocyanines; these synthesized substances produce a range of blues that can veer towards red at one end, but generally tend to be greenish.

Prepared turquoise colours

Cobalt Turquoise

Single pigment cobalt turquoises are also available. They give clear, bright colours in watercolour, and both bright and duller colours in oils and acrylics that are said to more closely resemble the opaque, matt appearance of the natural stone.

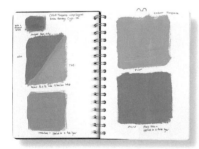

Experiment with turquoise

It is easy to mix numerous varieties of turquoise using chosen blue and green pigments, which allows precise control of the required bias of the colour.

Prepared turquoise

Manufacturers offer several colours named turquoise, but you can easily mix these hues.

(From left to right, top to bottom)
Phthalo Turquoise Light, Phthalo Turquoise, Turquoise Blue, Turquoise Deep, Turquoise Blue Deep, Phthalo Turquoise, Cobalt Teal, Cobalt Turquoise, Phthalo Turquoise, Cobalt Green Turquoise, Cobalt Blue Turquoise Light, Cobalt Turquoise (Hue).

Frequently 'turquoise' is used as an adjective to describe blue or green, depending on its particular bias.

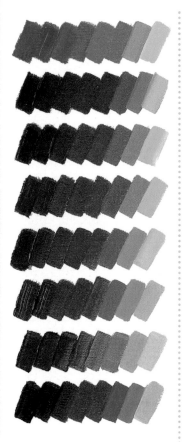

A complement to yellow

Violet is a secondary colour and is the complementary of yellow. The term violet is derived from the Old French 'violete' or 'violette', a plant or flower of the genus *Viola*, whose flower is of this colour. Violet lies at one end of the visible spectrum, next to blue.

Violet pigments

A number of violets exist as pure synthetic pigments. For example, PV15 (Ultramarine Violet), PV19 (Quinacridone) and PV23 (Dioxazine Violet) are frequently seen in product declarations on paint tubes. However, many manufactured colours that bear the name violet, including similar hues, such as the mauves, magentas and purples, are often combinations of red and blue pigments, sometimes with added white (see Light Blue Violet on page 23). Many of the prepared violet hues can be obtained by mixing colours.

From reds to blues

Together with mauve and purple, violet describes colours ranging from reddish blues to bluish reds and also violet-tinged reddish browns (Mars violets).

Caput Mortuum

This is a subdued violet-brown colour seen in artists' oil colours and sometimes in watercolours. Its strange name, 'death's head', which originated in the eighteenth century, is said to be derived from the colour of skulls piled in the catacombs in Rome. As none of the constituents of the pigment are obtained from bone a more feasible explanation is that the colour was obtained from iron salts that were baked down to their 'dying' embers. Caput Mortuum or Mars Violet has a subtle violet character that some artists find useful in their repertoire of earth colours. It makes good flesh tones when mixed with white.

Prepared violet
There are numerous manufactured violet hues available.

(From left to right, top to bottom)
Permanent Violet Dark, Caput Mortuum, Violet Bluish, Dioxazine Violet, Violet, Medium Violet, Light Blue Violet, Ultramarine Violet, Deep Violet, Quinacridone Violet, Light Violet, Brilliant Violet.

'I have finally discovered the colour of the atmosphere. It is violet.'
Claude Monet (1840–1926)

23

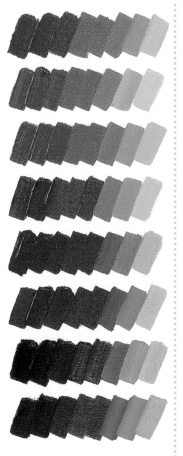

Dynamic and vibrant red

Red is the most dynamic and vibrant colour in the artist's palette. In its purest, saturated form it is the hottest of the warm colours. It is a colour that needs to be used judiciously, since overuse may reduce its vibrancy. Set against its complementary, green, even a small amount will sing and sparkle. It is one of the oldest colour names – the first colour word we speak after black and white.

Symbolic red

Red is a colour with countless symbolic and contradictory associations in different cultures. It can signify danger, or life; good luck, as well as evil. In India red is the sacred colour of Lakshmi, the goddess of wealth and beauty, and in China a ruby represents longevity. The red planet Mars is named after the Roman god of war. Early physicians wore red robes to signify their healing profession, and doors were painted with a red cross to signify the presence of the bubonic plague.

Red-letter day

What is red?

'Of or approaching the colour seen at least-refracted end of spectrum, of shades varying from crimson to bright brown and orange, esp. those seen in blood, rubies, glowing coals, human lips, and fox's hair.'
Oxford English Dictionary

Red-letter day

The early Christian church used red for directions in prayer books as to the conduct of church services and to show feast days on the ecclesiastical calendar, and so a red-letter day became a lucky day.

The first reds

Red was a difficult colour to make successfully and early pigments were often fugitive, turned black when mixed with others and were sometimes extremely toxic. Early red pigments were mostly made from earth colours, berries, roots, insects and resins, and many of the red paints were originally obtained from dyes. The Egyptians found a way of fixing dyes onto a transparent white powder (probably gypsum or even chalk); paint pigments made by this process are termed 'lakes'. Much later, Renaissance artists also used red lake pigments from resinous sources such as brazil wood, and the Indian lac and kermes insects.

Red lead

Once a highly prized colour, first manufactured by the Greeks, this pigment is not used by artists today since it is composed of lead monoxide and lead peroxide and therefore highly toxic. It is also known as Minium or Saturn Red. It was used for many years to protect steel from rusting.

Earth reds

Red iron-oxide pigments produce many reddish hues with similar properties, but slightly different variations, such as Mars Red and Venetian Red with light, warm tones and Indian Red, Mars Violet and Caput Mortuum, which are darker, cooler versions. Earth reds are permanent, lightfast colours with good covering power. Other colour names within this category are known as English Red, Pompeiian Red, Persian Red, Sinopia and Terra Rosa (see Brown and Red Earth, pages 56–63). These colours can be either natural or synthetic.

Realgar

Realgar was made from red arsenic sulphide. It was a natural pigment found in volcanic areas and hot springs, and was used in ancient Mesopotamia. The word realgar stems from 'rahj al-ghar' (Arabic for 'powder of the mine'). Now an obsolete pigment, realgar continued to be used until the nineteenth century when it was deleted from the artist's palette because of its extreme toxicity.

Cardinal Red
In the Middle Ages bright colours were rare since they were tedious and difficult to produce. Hence red became the exclusive preserve for kings, judges, the nobility, and the pope and his cardinals. In 1464 Pope Paul II introduced 'Cardinals' Purple', which was not purple at all, but a red dye made from the kermes insect.

Cinnabar
The chief mining area for cinnabar was Almaden in Spain. The Romans made paint from cinnabar and it was their only source of a bright orange-red colour. It was not as bright as Vermilion, though both are forms of mercuric sulphide.

'If one says "Red" (the name of a color) and there are 50 people listening, it can be expected that there will be 50 reds in their minds ...'
Josef Albers (1888-1976)

Cinnabar and Vermilion

Cinnabar, the precursor to Vermilion, was made from a dense hard rock. According to Theophrastus (*c.* 300BC) in *The History of Stones* cinnabar ore was dislodged from inaccessible cliffs by shooting arrows to loosen it.

Vermilion

The Greeks made an artificial form of cinnabar, called Vermilion, which was an orange-red pigment. The recipe was not known until the twelfth century in the West and it took another 300 years for the pigment to be in common use. Again it was the best bright red available. The colour was often used in manuscript painting where it was glazed with either egg yolk or 'glair' (egg white). Similarly in painting Vermilion was often glazed with madder or cochineal lakes in order to increase the purity of the colour. Vermilion is made by heating mercury and sulphur together in a flask. The combined substances vaporize and recondense at the top of the flask in the form of a black mixture. A red colour develops as the mixture is cleaned. The longer it is ground, the brighter the colour.

Cennini claimed that 'if you ground it every day for 20 years, the colour would still become finer and more handsome'. Vermilion continued to be used until the mid to late twentieth century.

Dragon's Blood
Also called Indian cinnabar by the Greeks. Pliny maintained that the colour came from a mixture of an elephant's and a dragon's blood, following a fierce battle between the two beasts. In fact, it is a red-brown resin produced by the sap of an Asian shrub known as *Calamus draco*. The leaves have prickly stalks that grow to resemble long tails and the bark is covered with spines.

Naming reds

A wide variety of reds is available for the artist in any of the media. Many of the colours are also known under secondary names – for instance, Alizarin Crimson is also referred to as Rose Madder or Permanent Madder.

Brand names

Some manufacturers attach their own names to colours they have developed, such as Winsor Red. There are individual inconsistencies that only become apparent to the artist after time and familiarity with a medium or particular paint manufacturer. Generally speaking, oil colours tend to have old names, while new media such as gouache or acrylic are often given more descriptive colour names. Flame Red, for example, is a gouache name that is very close in terms of handling and range of colour mixing abilities to the oil paint called Cadmium Red. Often an old name may be attached to a paint colour, but it is now made synthetically and the problems of permanence or toxicity that were associated with it in the past are no longer relevant.

These are some of the names you may come across to describe various hues of red pigments:

Alizarin Crimson
Bright Red
Brilliant Red
Burgundy
Cadmium Red
Carmine
Chinese Vermilion
Crimson
Florentine Red
French Vermilion
Genuine Red
Geranium
Helios Red
Intense Red
Magenta
Munich Lake
Nacarat Carmine
Naphthol Red
Pyrrole Red
Rose
Rowney Red
Ruby
Scarlet
Transparent Red
Vermilion
Winsor Red

Complementary colour

As the complementary of green, red is a useful colour for toning down bright saturated greens. Eventually the two mixed together with the addition of white will produce either a greenish grey or a warm pinkish grey.

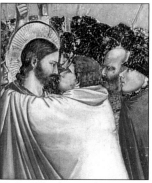

Giotto di Bondone (1267–1337) The Kiss of Judas, c. 1305–06 (detail)

'Judas hair'

A term used to denote bright-coloured hair in paintings, particularly red hair. The expression originated because artists traditionally gave Judas distinctive red hair in paintings.

Red legs
Natural madder produced the deepest and most permanent reds until the invention of Alizarin Crimson in the 1860s. The French government attempted to protect its traditional madder-growing industry by making it the compulsory red dye for army-uniform trousers.

Madders

Madder Lake and Rose Madder are now produced synthetically, but the colour was originally made from the root of the madder plant *Rubia tinctorum*. Native to Greece, it was introduced into France and Italy in the twelfth century. George Field, a great colourman of the nineteenth century, who supplied John Constable (1776–1837) and William Holman Hunt (1827–1910), invented a press in order to extract the dye from the madder root.

Genuine madders

Winsor & Newton are the only remaining large commercial company to produce a natural madder in artists' colours, one that has a pinkish rose hue. The pigment declaration NR9 shows the product contains genuine madder.

Dried madder root

Madder plant (*Rubia tinctorum*)

However, many modern colours bear the name madder, and these vary in hue from a medium rose colour to a darkish violet-brown (see page 29) and contain various synthetic organic pigment combinations.

Preparing natural madder: Alun Foster, chief chemist at Winsor & Newton

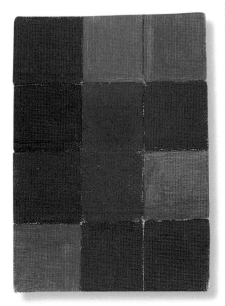

Synthetic madders range in hue from light, pinkish rose to deep reddish browns.

Crimson and Carmine

The original paint colours known as crimson or carmine were precursors of Alizarin Crimson. The names come from the kermes insect, from which this colour dye was first extracted. The sixteenth century saw the introduction of the same colour derived from the cochineal beetle *Dactylopius coccus*. This tiny Mexican *Coccus cacti*-eating insect produces a transparent and highly fugitive colour when ground and precipitated on clay. There are approximately 70,000 insects per pound of cochineal. The colour was held in high regard by the Aztecs, and was brought to Europe shortly after the discovery of Central and South America. It is more commonly used as a food colouring now since as a paint it proved to be extremely fugitive. Paints using the word carmine or crimson are now synthetically produced.

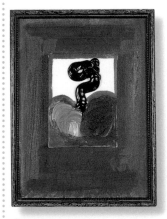

Alizarin Crimson
Alizarin Crimson is a synthetic substitute for madder and was first introduced by two German chemists, Graebe and Liebermann, in 1868. It was the first natural dye to be manufactured artificially. By 1920 it had replaced most of the old lakes and madders, which were often weak colours that discoloured rapidly and were not lightfast. Alizarin Crimson is a colour with a strong staining power – a little goes a long way. The colour is also transparent and is therefore used a lot with glazes.

29

Sample selection of quinacridones

Quinacridones
The first quinacridone colours were brought onto the market in the 1950s. These are a wide and vibrant range of reds that range through oranges, pinks and purples. They have gradually replaced most of the lake colours and provide new colours, particularly increasing the choice of bright magentas.

The new reds
The twentieth century saw the advent of new chemical pigments that have considerably augmented the artist's choice of reds. Many of these colours, such as the cadmiums, quinacridones and pyrroles, provide reliable versions of natural colours that are unstable.

Naphthol Red
Naphthol reds are a large group of organic pigments, first introduced in the 1920s. They range from yellow-shade reds right through to deep crimsons, and they belong to one of the most complex chemical families. The main factor that is of concern to artists is the variable lightfastness of the category, with some Naphthols being unsuitable for artists' colours. The more commonly used high-lightfast pigments appear as Naphthol Red Light, Naphthol Red Medium and Scarlet Lake.

Perylene Red
Developed in the 1980s, these are strong deep brown-red and maroon pigments. In mixes they produce warm darks.

Pyrrole Red
As their name implies, this is a group of bright, fiery orange-red colours. Introduced only in the 1990s, they are lightfast, have reasonable opacity and produce clean mixes that may have the advantage over cadmium colours.

Cadmium colours

In 1817 the heavy metal cadmium was discovered by the German scientist Friedrich Stromeyer. By the mid nineteenth century various cadmium colours were being developed. Brilliant in hue, they were opaque and also reliable to use. These colours all veer towards the hotter part of the spectrum through the red/orange/yellow range.

Using red to attract attention
Red attracts the attention of the viewer because the colour appears to advance, making red objects seem closer than they actually are. This visual phenomenon occurs because red has the longest wavelength of all visible light. Artists can use this property of red to their advantage for added dimension. Making some colours warmer will make them stand proud of a picture's surface, while cooler colours will appear to recede.

Cadmium Red

Cadmium Red was not introduced until the early 1900s, since when it has become a core red. Developed from Cadmium Yellow, Cadmium Red is made from cadmium sulphide and cadmium selenide. Top quality ranges are composed of pure cadmium, while cheaper makes are a cadmium-barium mix, which has less tinting strength and may produce a less vibrant colour.

Cadmium Red is one of the most important colours in the artist's palette and is the best substitute for Vermilion. It is a very bright, hot red. Very often paint manufacturers will have a variety of Cadmium Reds in their chart designated as light, medium and dark.

In a limited palette Cadmium Red is often balanced by the inclusion of Alizarin Crimson, which acts as a cooler red. It makes an opaque permanent colour, but there are some concerns with toxicity, particularly if neat pigment is used rather than ready-made paint.

Sample selection of cadmiums

Sample selection of magentas

31

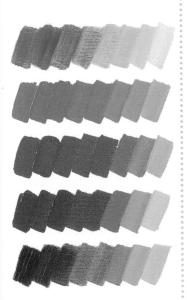

Warm and vibrant orange

The colour orange is named after the Sanskrit word 'narangah' for the fruit. Orange conjures up warmth and vibrancy and the colour appears in the hot part of the spectrum between red and yellow. In pigment form orange may often have a slight bias towards either red or yellow. Although it may be mixed from these two primaries, the clearest and brightest oranges are single-pigment hues.

Traditional orange

Orange has traditionally been sourced from earth colours ranging from golds to browns. The toxic Realgar, derived from volcanic minerals, which was used from ancient times and through the Renaissance period right up until the nineteenth century, could be classified as a red-orange. New mid oranges were developed from chromium and cadmium in the early 1800s, and recent improvements in synthetic colour manufacture have ensured reliable, lightfast versions of these.

Naming orange

Orange used as a name to describe a colour was unknown until the importation of the fruit into Europe in the Middle Ages. Even in the fifteenth century Cennini describes Realgar, which is an obvious orange hue, as a yellow.

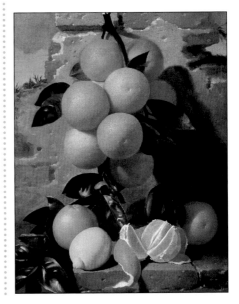

Antonio Mensaque
Oranges, 1863
Anglesey Abbey, Cambridgeshire
Collection of The National Trust

Burnt Orange
There are various hues carrying the descriptive name orange that veer towards transparent reddish browns. Among them are Chinese Orange and Quinacridone Burnt Orange.

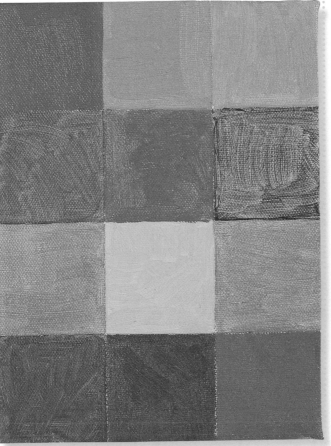

Manufactured oranges
Manufacturers offer several prepared orange hues. Many are single pigment oranges and will carry the declaration PO, followed by the appropriate reference number. Others are mixed pigments containing red PR and yellow PY ingredients.

(From top to bottom, left to right)
Cadmium Yellow Orange
 (Old Holland)
Scheveningen Orange
 (Old Holland)
Perinone Orange
 (Winsor & Newton)
Chrome Orange Hue
 (Rowney)
Brilliant Orange (Liquitex)
Cadmium Orange Azo (Talens)
Transparent Pyrrole Orange
 (Golden)
Cadmium Orange (Lukas)
Indo Orange Red (Liquitex)
Cadmium Orange (Tri-Art)
Cadmium Orange (Rowney)
Cadmium Orange (Maimeri)

'Warm red, intensified by a suitable yellow, is orange.'
Wassily Kandinsky (1866–1944)

'Orange is like a man, convinced of his own powers. Its note is that of the angelus, or of an old violin.'
Wassily Kandinsky (1866-1944)

Experimenting with orange
Orange exists as a single pigment (see page 33), but it is one of the easiest and most satisfying secondary colours to mix from reds and yellows.

Modern oranges

Advances in chemical synthesis in the twentieth century have given the artist new orange pigments that are bright, clear and lightfast. Among these colours are the perinone, benzimidazolone and pyrrole oranges.

Chrome Orange

This bright reddish orange was developed from chromium in 1809. It was produced by the reaction of lead nitrate with potassium chromate and sodium hydroxide, and the resulting mix was filtered and dried to produce the pigment. Different proportions of ingredients gave deeper shades. The chrome colours were not lightfast and most were later replaced by cadmiums. Chrome Orange was also known by several other names, including Persian Red and Derby Red.

Cadmium Orange

There is a huge number of cadmium colours that range from pale yellow to deep red. Cadmium was first discovered as a by-product of zinc production in the early part of the nineteenth century, but cadmium colours were not widely used until much later when cadmium was more generally available. Cadmium Orange is a bright warm colour that is composed of cadmium sulphide and cadmium selenide. It is a reliable, permanent colour and has good covering power. Some makers add Cadmium Red to Cadmium Orange to increase its reddish tone and the range of colours on offer to the artist.

Perinone Orange

An intense orange with a red bias, this colour was first used as a dye in the 1920s. Eventually produced as a lake pigment, it is available in light or dark shades. In watercolour it may appear to be a granular and semi-opaque pigment. It is lightfast and is sometimes combined with aluminium flakes to produce a copper-looking metallic paint.

Benzimidazolone Orange

This mid orange has a slight yellow bias. It is a reliable, staining colour and is often used now instead of Cadmium Orange. These 'azo' colours are often given

manufacturers' names; an example is Winsor Orange. They may not be quite as strong as cadmium colours when mixed, but they have good lightfast properties.

Pyrrole Orange

The pyrrole pigments were discovered in the early 1980s and give colours in the orange to red sector. Pyrrole Orange is a bright mid orange that is transparent and lightfast. This is another colour that may be used as a substitute for Cadmium Orange and it produces a broad range of colours when mixed.

A primary ingredient

Yellow is a versatile primary colour and an indispensable mixing ingredient in the artist's palette. The yellow family ranges in hue from acid cool green-yellows, through clean crisp lemons, by the way of pure unbiased primary yellows, rich warm cadmiums and chromes, and neutral creamy, fleshy Naples, to earthy ochres.

'There are painters who transform the sun into a yellow spot, but there are others who, thanks to their art and their intelligence, transform a yellow spot into the sun.'
Pablo Picasso (1881-1973)

What is Yellow?
'Of the colour between green and orange in the spectrum, coloured like buttercup or primrose or lemon or sulphur or gold'
Oxford English Dictionary

Yellows range in hue from extremely warm Naples Yellow Reddish (top left), to extremely cool Lemon Yellows (below left).

A contradictory colour
Yellow is perhaps the most contradictory of colours in terms of the associations it holds and the uses to which it is put. Yellow may suggest sunshine and cheerfulness, or sickness and cowardice. While yellow primroses and daffodils herald the spring, yellow and black stripes signal the warning of a wasp's sting, or the danger of heavy machinery. Yellow has highly emotive connections. Yellow ribbons tied on trees signify hope and optimism for returning loved ones.

The origins of yellow

Yellows are derived from the earth, from arsenic, plants and even cow's urine. The word 'yellow' comes from the Old English 'geolu'; and similar names for yellow are found in Old Saxon and Old High German ('gelo'), and in Old Norse ('gulr'). The Latin for yellow is *helvus* and a similar word Helios is the name of the Greek sun god, a name that has been appropriated to identify certain modern brands of yellow.

Prehistoric yellow

Yellow was one of the four colours used by the cave painters of the Stone Age; yellow and red earth, white chalk, and black carbon have been dubbed the 'prehistoric primaries'. The iron content in the earth gives the yellow and red hues a full, soft quality, evident in the cave paintings of Lascaux and Altamira. Yellow earths and ochres are still used to this day.

Massicot

A lead-monoxide earthy yellow pigment, massicot was a by-product of the production of red lead, made by the Ancient Greeks.

Yellow Ochre

Yellow ochres, or earths, have continued to be used throughout history and provide strong, economical, opaque colour. Yellow Ochre consists of a mixture of clay, siliceous matter and hydrated iron oxide (limonite). It is known by many names, including Earth Yellow, Mars Yellow and Mineral Yellow.

Orpiment

The Egyptians developed a brighter, more acidic yellow mineral pigment, a sulphide of arsenic, known as orpiment. It came from Smyrna and has been identified in Egyptian, Persian, Syrian and Chinese painting. It is mentioned in the writings of Pliny and, later, by Cennini. This highly poisonous and unpleasant-smelling colour was also used in medieval and Renaissance manuscript illumination, from Europe and Ireland to Persia and Byzantium. Much later it was made chemically and known as King's Yellow. Other names for it are Arsenic Yellow and Chinese Yellow.

Naming yellows

These are some of the names for yellows that you may see:

Aureolin	Indian Yellow
Azo Yellow	Lead-tin Yellow
Barium Yellow	Lemon Yellow
Brilliant Yellow	Massicot
Cadmium Lemon	Naples Yellow
Cadmium Yellow	Orpiment
	Paris Yellow
Chrome Yellow	Vanadium Yellow
Cobalt Yellow	Winsor Yellow
Gamboge	Yellow Ochre
Golden Ochre	Zinc Yellow
Hansa Yellow	

On the character of yellow colours according to Cennini

'A colour known as giallorino is yellow, and it is a manufactured one. It is very solid, and heavy as stone, and hard to break up. This colour is used in fresco and lasts for ever …, it is a very handsome yellow colour; for with this colour with other mixtures … attractive foliage and grass colours are made.'

'A colour known as orpiment is yellow. This colour is an artificial one. It is made by alchemy, and is really poisonous. And in colour it is a handsome yellow more closely resembling gold than any other colour. It is very good for painting on shields and lances. A mixture of this colour with Bagdad indigo gives a green colour for grasses and foliage … Beware of soiling your mouth with it, lest you suffer personal injury.'

**Cennino Cennini,
The Craftsman's Handbook
(Fifteenth century)**

The character of yellow

Plant yellows
Turmeric and saffron have been used as colours. Saffron is a bright yellow colour obtained from *Crocus sativus*, but is said to fade badly in daylight.

Gold
Heraldic convention ignores yellow as a colour, but uses it to represent gold. Real gold leaf was reserved for the most prestigious and sacred works of art. Fifteenth and sixteenth-century writings refer to the use of powdered gold as a watercolour for illuminating manuscripts. The grinding of gold as a pigment is a difficult process because of the softness of the metal, but there is mention of ground gold being suspended in honey as a binder.

The gold-leaf maker
'… hammers gold thin for painters, illuminators and other artists; gold is ground and rubbed into writing material; it is also woven and sewn into textiles … .'
Standebüch (The Book of Trades), Nuremberg, 1568

Gamboge
This yellow pigment from Cambodia was first imported into Europe in the seventeenth century. Derived from the resin of the *Garcinia hanburyi* tree, it incorporates its own binder. The colour is moderately lightfast, so is only suitable for watercolour use.

Indian Yellow

Along with Mummy Brown the process of obtaining Indian Yellow may be considered rather offensive. It is reputed to have involved precipitating the urine of cows that had been force-fed with mango leaves. Its manufacture, from just one village, was banned in the 1920s by the Indian government in an effort to protect the cows from such an unhealthy diet. This bright, golden colour is now replicated chemically, though it may lack the precise character of the original! Indian Yellow was most successful for watercolour, and had substantial lightfast properties. It is the bright yellow used in jewel-like Indian miniatures.

Helios

The Greek sun god Helios is often represented as a charioteer driving the sun across the sky. Helios and Helio have been adopted as appropriate brand names for certain bright yellow pigments.

Plant yellows

Yellow 'pinks'

Up until the end of the seventeenth and even into the early eighteenth century the word 'pink' was often used to describe yellow hues. Many of these yellows were derived from plants and berries, and other natural sources such as seashells. A 'pink' was produced by dyeing a white substance such as chalk, and was in effect a chemically simplified version of a lake.

Among the 'pink' names you may see to describe colours with a decidedly brownish-yellow hue are; Brown Pink (top), Italian Pink (middle) and Stil de Grain (bottom).

Cadmium Yellow
In the late 1840s cadmium yellows were introduced. Made from cadmium sulphide, the pigment was expensive. Cadmium colours still offer an important element in the artist's palette. As well as providing a range of hues, they have good durability and heat resistance, although humid atmospheres may affect their lightfast properties. Manufacturers usually offer Cadmium Yellow in three tones – light, medium and deep – ranging from pale primrose, to golden, to orange. There are also different tones of Cadmium Lemon.

Modern yellows

The advances in chemistry during the eighteenth and nineteenth centuries brought a wide range of new yellows. Particularly important were the yellow pigments that were derived from chromium and cadmium.

Artists today call on core yellows that include many cadmium colours as well as colours with traditional and historical pedigrees. With the exception of natural Yellow Ochre, nearly all of these latter colours are made of synthetic ingredients, which ensures their permanence.

Chrome Yellow

The metal chromium was discovered in 1797 by N. L. Vauquelin, a French chemist. Its constituents were of various colours, so he named it 'chrome' (from Greek for 'colour'). Vauquelin developed Chrome Yellow by mixing lead acetate or lead nitrate with potassium chromate to produce lead chromate. Manufacture of this colour began in the early 1800s and was in full flow by 1820. Similar in hue to orpiment, it soon replaced its poisonous predecessor, but it had disadvantages too.

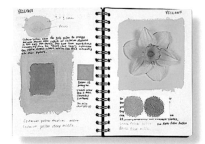

It had a tendency to discolour on exposure to light and became darker as it aged. Chrome Yellow was also known as Paris Yellow or Leipzig Yellow. The colour has now largely been replaced by the more reliable cadmiums.

Chrome Lemon

By altering the amount of lead chromate in the pigment a range of different colours could be produced from chromium, from a pale primrose to a deep orange-scarlet colour. By about 1830 three further pigments were developed from chromium. These were barium chromate, strontium chromate and zinc yellow, and all were sold as Lemon Yellow. All three colours were semi-transparent, but the most permanent was strontium, which was a cool, light yellow. Again, however, even strontium tended to go greenish in oils.

Aureolin

A cobalt yellow became available in the 1860s when William Winsor introduced Aureolin. The colour was developed from a cobalt salt precipitated in acid solution with a solution of potassium nitrite. An expensive pigment, it has good lightfast properties, but it can decompose when subjected to heat or a change in acidity. The colour is most suitable as a watercolour.

Hansa yellows

The Hansa yellows were developed by the German chemical company Hoechst at the beginning of the twentieth century. They are derived from 'azo' dyes, after which the colours are sometimes named. You may also see them with trade or brand names, such as Winsor Yellow. The colours range from cool lemon yellows to warm golden yellows. Significantly, as such bright colours, they do not darken when used fully saturated.

Naples Yellow

A favourite colour among painters, Naples Yellow, sometimes known as Antimony Yellow, was used in European painting as early as the fourteenth century. It is believed that its original source was the volcanic earth of Mount Vesuvius near Naples, but by the seventeenth century the colour was made from lead antimoniate. Today Naples Yellow is made with various pigments. The colour is widely available in oil paint in light, medium and deep tones and in warm pinkish yellow hues too. It is also produced as watercolour and acrylic. Artists generally find it lightfast, with excellent handling qualities.

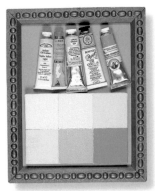

A selection of Naples Yellows

Warm yellows
(Right, from top to bottom)
Naples Yellow, Naples Yellow Deep, Naples Yellow Reddish. Some manufacturers offer pinkish combination pigments that fall into the yellow name category, but look more pink than yellow. Examples of these colours are Jaune Brillant and the Naples Yellow Reddish hues.

41

Van Gogh and yellow

Vincent van Gogh (1853–90) often used yellow in his vibrant paintings. Setting up studio in Arles, the south of France, in the Yellow House, he painted his surroundings of cornfields, sunflowers and yellow rooms.

Unfortunately, many of Vincent's vivid yellows have not aged well. In the nineteenth century many artists adopted chrome yellows to replace earlier yellow pigments that were unreliable or susceptible to fading, such as Gamboge and original Indian Yellow. But, Chrome Yellow, too, brought problems and in many paintings the colour has turned green and in some cases nearly black. Even van Gogh's famous sunflowers have darkened and the rather sickly yellows that appear in many of his pictures are signs that the Chrome Yellow is deteriorating.

Pigment formulations

Most yellows are made from a single pigment formulation and employ chemicals such as cadmium zinc sulphide, arylamide, nickel titanate, potassium cobaltrinitrate and natural iron oxides. A few members of the yellow family are combination pigments, which

can be approximated in mixes. Cadmium Yellow Deep is a good example where the yellow element has been warmed up with orange to give deeper hues. Naples Yellows have been softened and neutralized with additional white and ochres, and are closely related to earth and oxide colours in hue and density.

Lemon Yellow

Lemon Yellow may now be made from one of the arylamide synthetic organic pigments or nickel titanate. The colour is a cool, clear acidic yellow that is considered useful for mixing powerful greens and oranges. It is transparent, with a rather weak tinting power.

'... it would be easy to define by association the physical effects of colour, not only upon the eye but the other senses. One might say that bright yellow looks sour, because it recalls the taste of a lemon.'
Wassily Kandinsky (1866–1944)

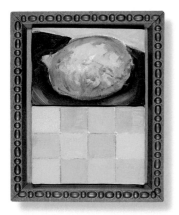

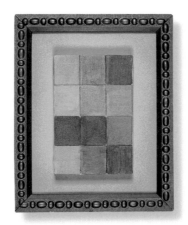

Indian Yellow, Gamboge and Golden Yellows

Nearly all of of the older pigment yellows are now synthesized from combinations of red and yellow pigments. Indian Yellow is formulated from diarylide yellow pigment PY83 and synthetic iron oxide PR101. Many of the closer hues, often named Golden Yellows in catalogues, share similar ingredients. The exception is Gamboge Genuine, which is still available made from naturally occurring Gum resin NY24.

Yellow Ochre

Yellow Ochre is a natural mineral yellow and has been used since prehistoric times. The colour is still made from natural iron oxide PY43 (see page 44). Many other ochre colours, such as Gold Ochre, may now be replicated by synthetic iron oxide ingredients (see Brown and Red Earth pages 56–63).

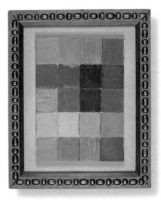

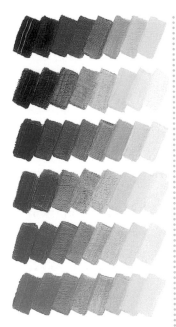

A prehistoric pigment

Yellow Ochre is a dull yellow earth pigment. It is one of the oldest natural minerals and has been in use since prehistoric times. Like all earth pigments, it is mined from surface deposits and is therefore easily accessible and fairly cheap to obtain.

The natural yellow iron-oxide pigment is PY43. Yellow Ochre is usually listed among the yellows in art materials manufacturers' literature and its hue can vary from a reddish brown to an earthy, golden yellow. It is said that the higher the iron content in the pigment the darker the hue becomes.

Palaeolithic cave paintings, c. 15,000BC
As far as we can tell, the Palaeolithic artists used a limited palette of three colourfast pigments: yellow, red and black. All the colours are based on iron-oxide deposits from the earth, and carbon, thought to be from fire ashes.

Synthetic and natural ochres

Since the 1920s manufacturers have also used synthetic yellow iron oxide PY42, which replicates the permanent and lightfast qualities of mined Yellow Ochre. However, it can sometimes be more transparent because of the absence of clay. Natural Yellow Ochre PY43 is found in many places including India, South Africa, Italy and the USA. France also has good deposits of high grade ochre. Past names such as Oxford Ochre from the Shotover Hills, Oxford, England, relate to other sources of the colour.

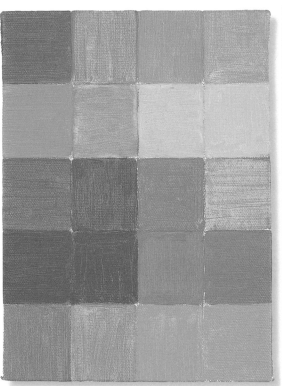

(Above) **A selection of colours whose ingredient is PY42**
(Left) **Natural iron oxide deposits**

Ochres
A selection of colours whose ingredient is PY42, synthetic yellow iron oxide. Ochre hues can vary from light brownish yellows to darker reddish yellows.

Other ochres to be found are:
Attish Light Ochre
Bronze Yellow
Burnt Yellow Ochre
Deep Ochre
Flesh Ochre
Gold/Golden Ochre
Mars Yellow
Nickel Azo Yellow
Orange Ochre
Roman Ochre
Yellow Oxide

(Below) **Modern Ochre pigment production at the Maimeri plant in Italy**

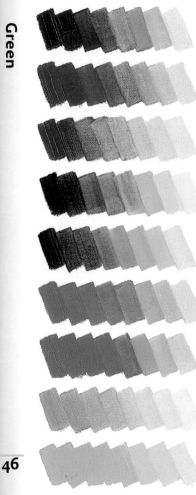

Between yellow and blue

Chlorophyll is the source of green in the earth's vegetation. It traps the sunlight and retains the red and blue-violet parts of the visible spectrum, allowing the green portion to be reflected. Green lies between yellow and blue in the colour spectrum and is readily mixable on the palette from blue and yellow.

'Grass green and aspen-green, Laurel-green and sea-green, Fine-emerald green,
And many another hue;
As green commands the
variables of green
So love my loves of you.'
Robert Graves (1895-1985)
Variables of Green

copper green derived from a basic carbonate of copper. It is found in many parts of the world, usually in association with azurite. Among the obsolete names for this bright green pigment are Mineral Green, Mountain Green and Hungarian Green.

Green in history
Most descriptions of early green pigments refer to copper and arsenic ingredients, which were common until the invention of synthetic pigments in the nineteenth century.

Copper green and malachite
The history of malachite runs closely parallel to that of azurite (see Blue, page 13). Malachite is a naturally occurring

Cennini writes of the virtues of malachite in the fifteenth century:

'A half natural colour is green; and this is produced artificially, for it is formed out of azurite; and it is called malachite This colour is good in secco, with a tempera of yolk of egg, for making trees and foliage, and for laying in.'

Chrysocolla

In classical and medieval writing there are references to a blue-green mineral known as chrysocolla, found in combination with malachite. The name is derived from the Greek words for 'gold' and 'glue', since it was used by the ancients for soldering gold. Chrysocolla has been identified in wall paintings in China and Central Asia and in Egyptian tombs dating to 2000BC.

Scheele's Green

In 1775, while experimenting with arsenic, Swedish chemist Carl Wilhelm Scheele discovered an acid, copper arsenite. Scheele did not immediately publish details for the manufacture of this copper green pigment because he felt that potential users should be first aware of its poisonous nature. The colour was later named after him, but there is some doubt about the extent to which Scheele's Green was used by artists. It is not mentioned in literary sources of the period except for the following account in 1869:

Carl Wilhelm Scheele (1742-86)

' ... To make the green, some potash and pulverised "white arsenic" (that is arsenious oxide) were dissolved in water and then heated, and the alkaline solution was added, a little at a time because of effervescence, to a warm solution of copper sulphate. The mixture was allowed to stand so that the green precipitate could settle, the liquid was poured off, and the pigment was then dried under a gentle heat '
George Field's *Chromatography* (1869)

Pigment green (PG)

In art materials terms green exists as a pigment in its own right, identified on products as PG (pigment green). For example, you will come across PG7 Phthalo Green, PG8 Naphthol Green, and PG18 Viridian as single pigments. Conversely, several greens on offer are made of combinations of pigments and contain yellow, blue and white (see page 51).

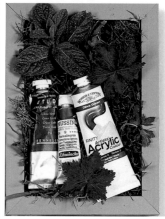

Naming greens

Green is the largest colour family discernible to the human eye. Prior to the standardization of pigment nomenclature many names were used to describe hues of green. Some of the following names are still in current use, while many have now disappeared:

Almond Green
Apple Green
Arnaudon's
 Green
Avocado Green
Bottle Green
Brunswick
 Green
Casali's Green
Celadon Green
Chartreuse
Chlorophyll
Chrome Green
Cinnabar
Cobalt Green
Copper Green
Dingler's Green
Emerald Green
Evergreen
Hungarian
 Green
Jade Green
Kelly Green

Leaf Green
Leek Green
Lily Green
Mineral Green
Mittler's Green
Moss Green
Mountain Green
Munich Green
Myrtle Green
Nitrate Green
Pansy Green
Paris Green
Plessy's Green
Prussian Green
Scheele's Green
Schnitzer's
 Green
Schweinfurt
 Green
Verdigris
Vienna Green
Woodland
 Green

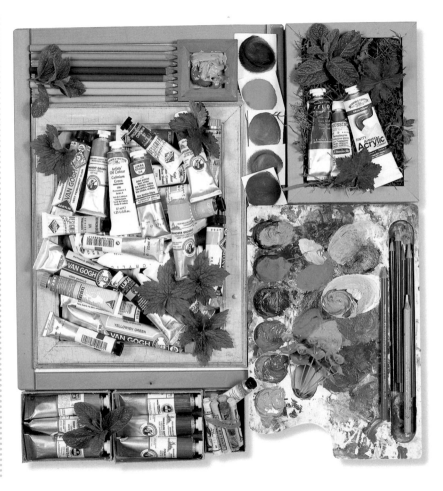

Vegetable and mineral greens

Vegetable greens

Green pigments were extracted from flower petals in the seventeenth century and lake colours with names such as Pansy Green, Lily Green, Iris and Honeysuckle were created. Sap Green, a name still in use to describe a bright leafy colour, was made from ripe buckthorn (*Rhamnus*) berries and is mentioned frequently from the twelfth century. In the eighteenth century Sap Green became popular for use in watercolour. It was also termed Bladder Green because it was often stored in bladders.

Sap Green
Today the vegetable ingredient of Sap Green is replaced by modern arylide, phthalocyanine or naphthol pigments.

Chromium oxide green

Chromium Green

This is a dull greyish green derived from chromates or chromium, which was discovered by Nicolas Vauquelin in 1797 in a mineral known as Siberian red lead, later known as chrocoite. Many coloured compounds including Chrome Red and Chrome Yellow were derived from chromium (see Chrome Yellow, page 40). Of chromium oxide greens, Vauquelin wrote:

'On account of the beautiful emerald colour it communicates, ... will furnish painters ... with the means of enriching their pictures, and of improving their art.'

Verdigris

Verdigris (from the French meaning 'green of Greece') is a blue-green pigment made by scraping the patina from copper that has been exposed to vinegar or wine. It is the most well known of the early artificially prepared green copper pigments. Its production originated in wine-growing areas and it was made by alternately stacking copper sheets and grape husks. A crust would form on the surface of the copper sheets and, when scraped off, the scrapings were pulverized to produce a light blue powder sold as verdigris. Verdigris is not seen nowadays as an artists' pigment, but *Vert antique* is a decorative finish used for bronzing plaster casts and other surfaces.

Phthalo greens
A vast number of green hues are available in manufacturers' catalogues and one of the main ingredients used is Phthalo Green, even though some original pigment names are still incorporated as a description on the tube. This modern organic pigment, introduced in 1938, was a product of artificial dyestuffs. The pigment is from brominated or chlorinated copper phthalocyanine. Its colour is similar to the bright, traditional Emerald Greens, which contained the minerals copper and arsenic.

Phthalo-based greens

Phthalo Green (PG7 and PG36) has excellent lightfast qualities and high permanence in all media and is produced by most manufacturers under the name Phthalo Green and a variety of trade name variations.

Other very widely used greens, all of which rely on Phthalo but have a modern yellow pigment added, are the bright mid greens named Permanent, Cadmium, Emerald, Yellowish, Chrome, Cinnabar, and the blackish blue-green, Hooker's.

Sap Green, a bright leafy colour produced since the Middle Ages, originally from unripe buckthorn berries, is now synthesized from Phthalo or Naphthol Green.

Even the popular Viridian Green is today often made from Phthalo. Olive Green, originally made from fugitive lakes, uses Phthalo Green pigment as a base, mixed with a variety of red, yellow, orange, blue or violet.

Exceptions

Exceptions to the extensive Phthalo usage is the greyish green Chromium Oxide, consistently made from its oxide of chromium pigment, compared to Chrome Green made from Prussian Blue and Chrome Yellow. Cobalt Green, a bluish version of Emerald, is made from a cobalt oxide and Green Earth (Terre Verte or Green Umber), a blue-grey green, which usually consists of the natural inorganic pigment (see Green Earth, page 54).

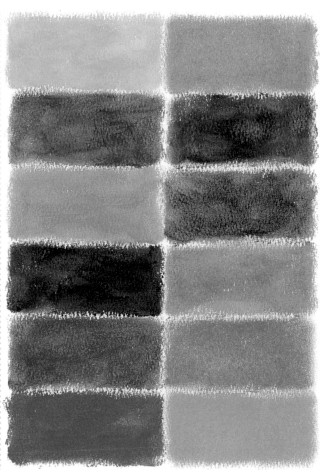

Hooker's Green
William Hooker painted pottery and may be the source of this name. Hooker's Green is a mid green with a blackish undertone. Originally a mixture of Gamboge and Prussian Blue and considered an unreliable pigment, it is now based on more modern pigments such as Phthalo Green and Cadmium Yellow.

Prepared greens
You will see various names in colour charts. Some of them are single pigments and others are combinations of pigments. The list (below) gives an average guide to formulations, which will vary from manufacturer to manufacturer.

(From top to bottom, left to right)
Cadmium Green
 (PG18 or PG7 + PY35/PY37)
Chromium Oxide Green
 (PG17)
Cinnabar
 (PG7 or PG36 or PG18 +
 PY1/3/35/42)
Cobalt Green
 (PG19 sometimes PG26 or PG50)
Emerald Green
 (PG7 or PG36 + PY1/3/97/154)
Hooker's Green
 (PG7 or PG36 + PY3 or PY42)
Olive Green
 (PG7 + PY42/PR101/PBr7)
Permanent Green
 (PG7 +PY1/3/35/128)
Phthalo Green
 (PG7 or PG36)
Sap Green
 (PG7 or PG8 or PG36 +
 PY1/42/73/83)
Viridian Green
 (PG18 or PG7)
Yellowish Green
 (PG7 or PG36 + PY3/74/154)

Experimenting with green

Many ready-made greens are very clean and bright and are difficult to replicate. However, at its simplest, green is a combination of blue and yellow, and many manufacturers recommend the best blues and yellows to buy for the purest mixtures. Experimentation with different types and proportions of blue and yellow can lead to interesting results.

Sketchbook experiments with blue and yellow mixing combinations (right).

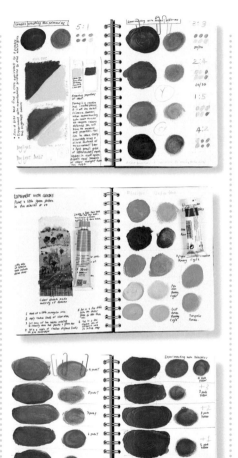

Green sketch

Ready-made acrylics were used to create this green sketch – light leaf green for the hills, pale olive for the mid ground, opaque oxide of chrome for the foreground, and finally a light green again. The details are Viridian.

Green tints
The little canvas example shows how the range of ready-made greens is increased by simply adding white to create a tint.

(From top to bottom, left to right)
Cobalt Green Deep (Winsor & Newton)
Phthalo Green Yellow Shade (Golden)
Phthalo Green Blue Shade (Golden)
Viridian (Lukas)
Emerald Green (Winsor & Newton)
Hooker's Green Hue (Liquitex)
Bohemian Green Earth (Lukas)
Permanent Green Light (Tri-Art)
Chrome Oxide Green (Golden)
Sap Green (Lukas)
Olive Green (Rowney)
Permanent Green (Winsor & Newton)

Complementary opposites
Green is a secondary colour, and the opposite to red. This complementary colour combination of red and green has contributed to the vibrant energy in the design of many paintings.

'I tried to express through red and green the terrible passions of humanity.'
Van Gogh on his painting *The Night Café*

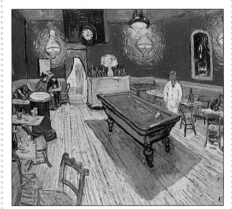

Vincent van Gogh (1853-90)
The Night Café, 1888
Oil on canvas (detail)
70 x 89cm (27½ x 35in)
Yale University Art Gallery

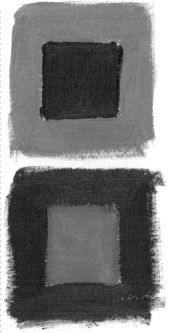

Why do two colours, put one next to the other, sing? Can one really explain this? No. Just as one can never learn how to paint.'
Pablo Picasso (1881-1973)

53

Terre Verte or Green Earth

Green Earth is a natural pigment (PG23), ranging in colour from yellow-olive green to a grey-blue green. It is one of the earliest known pigments and is commonly known as Terre Verte or Terra Verde. Its origins, unlike other earth pigments, which are iron oxides, are commonly from marine clays containing iron silicate. The mineral contents are mainly celadonite (bluish grey) or glauconite (brownish olive).

Green Earth colours
A variety of Green Earths and hues are similar to traditional Terre Verte. Green Earth colours are available from most manufacturers in nearly all the popular artists' media.

Natural and synthetic sources
Green Earth sources are not as widespread as iron oxides and the natural deposits of the pigment, mainly from Cyprus and central Europe, are almost exhausted. A famous source of the

mineral was near Verona in Italy; hence its name Terra verde di Verona, dating to the Middle Ages. Current manufacturers may replace the natural earth with Phthalo (PG7) or Viridian (PG18) plus yellow or brown oxide.

Origins of Green Earth

Creta viridis

Records of Green Earth date back to
Roman times, when it was used as a base
for frescos and called *Creta viridis*. It has
also been discovered in wall paintings in
Pompeii, Asia Minor and India. In medieval
and Renaissance painting, Green Earth was
incorporated as an underpainting for flesh
tones. Natural Green Earth is translucent
and has a high oil absorption, and is well
suited to water-based media. In the past
the pigment was mixed with various
plants, such as parsley, rue and columbine
to enhance its greenness. When heated,
Green Earth turns brown and is sometimes
known as Green Umber.

Examples of Green Earth
(From left to right, top to bottom)
Green Earth (Talens)
Green Earth (Sennelier)
Green Umber (Lukas Studio)
Olive Green (Talens)
Green Umber (Lukas Sorte 1)
Rowney Olive (Designers' Gouache)
Bohemian Green Earth (Lukas Studio Oil)
Rowney Olive (Artists' Oil)
Bohemian Green Earth (Lukas Gouache)
Green Earth (Old Holland)
Olive Green (Winsor & Newton)
Greenish Umber (Talens)

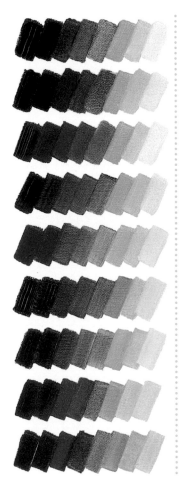

Brown and Red Earth

Raw and Burnt Sienna, Raw and Burnt Umber, the red-brown oxide colours such as Venetian and Indian Red, and Yellow Ochre, Red Ochre and Terre Verte (Green Earth) are all earth colours. They are some of the oldest pigments known to man.

Substances from the ground

Burnt Sienna is produced by roasting the raw pigment, named after the Italian city near which it was first found, and Burnt Umber is made in a similar way. Earth pigments come from clay and other substances in the ground. Cennino Cennini describes (see right) the wonder of seeing these colours of the earth.

Spanish Brown

In the frequent mentions of Brown Ochre under this name is the charge that it was coarse and gritty. The best ochres traditionally come from France, and range from light yellow to deep red.

The greatest wonder in the world

'And upon reaching a little valley, a very wild steep place, scraping the steep with a spade, I beheld seams of many kinds of colour: ochre, dark and light sinoper, blue, and white; and this I held the greatest wonder in the world – that white could exist in a seam of earth ... And these colours showed up in this earth just the way a wrinkle shows in the face of a man or woman.'
Cennino Cennini,
The Craftsman's Handbook (Fifteenth Century)

Ochres and oxides

Earth pigments

These very ancient rich mineral sources produce yellow, red, brown and green pigments, depending on the natural iron-oxide colouring agent in the deposits. They were used in prehistoric cave paintings and are probably the most permanent colours available as they are little affected by atmospheric conditions. The minerals are dug from the earth, washed and then ground to produce the pigments.

Ancient earth pigments
It is thought that oxides of iron were dug right out of the ground in the form of lumps that were rich in clay, and that the blacks were derived from manganese ores, charcoal and ashes. The raw pigments were then ground with various fluids such as blood, urine, animal fat, saliva and bone marrow to make a paintlike paste.

Red Ochre and iron oxides

These natural pigments range in colour from dull yellow (see page 44) to red and brown. Ochres and oxides in art have a long history.

Red Ochre is a warm red-brown earth colour and is based on deposits of hematite (see page 58). Traditionally, Spain and the Persian Gulf were excellent sources of this iron oxide and the large variety of names used for the colour relate to its original source locations. Red Ochre can also be produced from calcined (roasted) Yellow Ochre. The colour was used in medieval times for fresco painting and for oil-painting grounds because of its quick drying time and low oil-absorption qualities.

Some other reddish ochre hues are:

English Red	Pozzuoli Red
Indian Red	Red Oxide
Light Red	Sinopia
Mars Orange	Spanish Red
Mars Red	Terra Rosa
Persian Red	Turkey Red
Pompeiian Red	Venetian Red

'Give me mud and I will paint you the skin of Venus.'
Eugene Delacroix (1798–1863)

Brown Ochre
Brown Ochre is another reddish brown, but the name is not used as much as the other ochres. The natural iron-oxide pigment is PBr7 and it is widely used today in the manufacture of siennas and umbers. In seventeenth-century England this colour was sometimes described as Spanish Brown. It was prepared by heating Red Ochre, the name relating to its similarity to the natural Red Ochre from Spain. However, there are references to Spanish Brown as a synonym for Vandyke Brown. Mars Brown (PBr6) is the modern synthetic version.

57

Iron ores and reddish browns

Iron oxide is a principal colouring agent derived from four main types of iron ore: hematite, limonite, magnetite, and siderite.

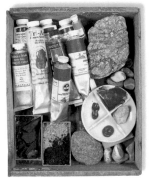

Hematite

Most iron oxides come from hematite and limonite ores. Hematite is a name derived from the Greek *hema* (meaning 'blood'). Hematite means 'bloodlike' and refers to natural red earth. A hard, compact and pure natural variety of anhydrous ferric oxide is used in the production of dark red pigments.

Sinopia

This is the old Latin name for natural red earth pigment. More particularly, it is an obsolete name for the red iron-oxide pigment derived from Sinope, the Turkish town on the Black Sea, where it is mined. This was an important classical source of red oxide. In the fifteenth century Cennini recorded 'a natural colour known as sinoper', which when mixed with lime white was 'very perfect for doing flesh, or making flesh colours of figures on a wall.' The colour was often used for the underdrawing on plaster in mural painting and the drawing itself was called the 'sinopia'.

Synthetic oxides

Natural iron-oxide pigments are still in use today and are considered among the most permanent colours available. Most are not affected by atmospheric conditions and most of the pigments are non-hazardous. Iron-oxide paints resist corrosion and the distinctive red-brown hue is commonly seen as a basecoat protection on raw steel. Since the eighteenth century a synthetic product, Mars Red (PR101), has been used as a substitute for the natural red earth pigments as it has similar properties of durability and permanence. Most red oxides today are produced from the synthetic pigment.

Versatile brown

Not drab at all

Browns are generally considered to be drab colours (see the Winston Churchill quote below), but this is clearly untrue when viewing the variety of brownish hues and earth pigments on offer. Their documented usage from prehistoric times to the present day indicates the reliability and popularity of these easily obtainable and permanent colours.

'I cannot pretend to feel impartial about colours. I rejoice with the brilliant ones, and am genuinely sorry for the poor browns.'
Winston S. Churchill
***Thoughts and Adventures* (1932)**

When reading the above, one cannot help but get the feeling that Churchill had a prejudice against the more sombre end of the palette and did not fully appreciate that browns represented a wide yet subtle colour range in the artist's repertoire.

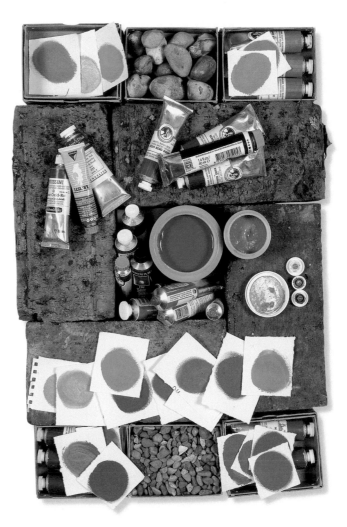

Vandyke Brown

This brown ranges from pale to black in colour. Its original composition was of humus or vegetable earth ingredients in the form of peat or lignite, plus iron. The colour was popular with Flemish painters such as Rubens, Rembrandt and van Dyck, after whom it is named. It is also known as Kassel Earth, from the place in Germany where the natural ingredients were found. In its original formulation the pigment is not permanent and it fades.

Owing to its transparency artists found it useful for shading and wood staining. Vandyke Brown is often substituted by Umber. The natural pigment bituminous earth (NBr8) is still available and used. However, most modern ingredients for this colour consist of synthetic red oxide (PR101) or natural iron oxide (PBr7) plus black. Other names are Cassel Earth, Cologne Earth, and sometimes Ruben's Brown, although this name is seen in association with Brown Madder too.

Sir Anthony van Dyck (1599–1641)

Various versions of Vandyke Brown as pure colour and in tint with Titanium White.

Sepia

This organic pigment originates from the ink-sacs of cuttlefish (*Sepia officinalis*), found in the Adriatic Sea. Sepia is reputed to have been used by the Romans as an ink, but its popularity was marked after 1780 by its introduction by Prof. Jacob C. Seydelmann in Dresden. It was used mainly as a watercolour or ink. Today's colours named Sepia are synthesized using black, brown or red oxide pigments.

The descriptive 'Mars' may have originated from the name given by alchemists for iron or to the yellow ochre-coloured pigment formed through oxidization of iron in air, *crocus martis*, of which the literal translation is simply Mars Yellow.

Other frequently seen colours bearing the prefix are: Mars Yellow, similar to Yellow Ochre; Mars Orange, a cross between Red and Yellow Ochre; and Mars Red, similar to the red ochres, which can range from scarlet to maroon.

Mars colours

Mars colours are artificial iron oxides. Used as substitutes for natural earth pigments, they are often more brilliant and opaque with higher tinting strengths. Like the natural oxides they are highly permanent. Mars Brown is a mid-chocolate shade, generally made from pigments PR101 and black. Mars Violet contains synthetic red oxide (PR101) and is a chocolate purple-brown, also known as Caput Mortuum and Violet Oxide. Mars Black is a dense neutral black.

Mummy Brown
A brown pigment made from asphaltum used for embalming, this was originally obtained from Egyptian tombs. Its recorded usage as an art colour was from the 1800s until the 1920s.

Asphaltum

Also called Bitumen this ancient blackish brown colour, composed of modified organic matter, is not a true pigment. It is made from asphalt, a natural resin often sourced from Trinidad or the Dead Sea, which is dissolved in oil or turpentine. It was popular with van Dyck, and because of its instability it was used thinly. It dries badly, cracks and wrinkles. Since the nineteenth century it has been replaced with synthetic coal-tar dyestuffs, and today's asphaltum uses combinations of modern yellow, red, green, violet and black. However, a natural black exists, NBk6 (trade name Gilsonite), and is still available as an oil paint.

Pozzuoli Earth

A native red earth pigment from Pozzuoli near Naples, this is the traditional brown-red used in the frescos of the Italian Renaissance. The colour produces a clean, bright reddish hue and it is renowned for its unique property of setting as hard as cement. Some makers still offer a synthetic red oxide pigment that bears the name Pozzuoli Earth or Pozzuoli Red, and there are many similar hues available too, such as Terra Rosa and Venetian Red.

Bistre

This is a yellowish brown pigment made from boiling the soot produced through burning beechwood. It was used from the fourteenth to the nineteenth centuries in watercolour or in tonal wash drawings. The pigment is now replaced with Burnt or Raw Umber.

Brown Madder

A brownish crimson-orange colour, originally derived from madder (see page 28), this was also known as Ruben's Madder. Now based on Alizarin Crimson (PR83), it is a transparent permanent lake, and current formulations may contain red, brown, yellow and green pigments.

Sienna and Umber

Raw Sienna

This orange-brown colour is produced from a natural yellow-brown earth oxide. The natural clays contain iron and manganese, the finest variety of earth, and were originally mined near Siena in Tuscany, Italy. The deposits are now depleted and the source of the pigment has been superseded by other regions in Italy, particularly Sardinia and Sicily. Raw Sienna is one of the most permanent pigments. Current manufacturers of the colour often use synthetic yellow (PY42) or red oxides (PR101). Some producers still employ natural oxides, also known as Italian Earth and Terra di Siena.

Burnt Sienna

A warm red-brown, produced by calcining (roasting) Raw Sienna, this is an extremely permanent pigment, clean and transparent. Because of its lack of chalkiness, it is perfect for mixtures of dark colours. Like Raw Sienna, modern production uses either synthetic red oxide (PR101) or the natural iron oxide (PBr7).

Raw Umber

A greenish brown earth colour, Raw Umber is obtained from oxides containing iron and manganese. The name is thought to originate from the Latin umbra (meaning 'shadow'), as the pigment was often used for shadows and shading other colours. It is a highly permanent, transparent and lightfast pigment. Records indicate its use since the 1600s. Most modern umbers consist of natural oxide (PBr7), but some use a mix of synthetic oxides (PY42 and PR101). Also known as Cyprus Umber, Turkey Brown and Sicilian Brown.

Burnt Umber

Produced by calcining Raw Umber, this is a darker reddish brown with similar properties to Raw Umber, but more transparent. Current pigments mainly use natural iron oxide (PBr7), although combinations of synthetic oxides (PY42 and PR101) and black are also manufactured. Old names for Burnt Umber include Chestnut Brown, Euchrome and Jacaranta Brown.

Raw and Burnt Siennas

Raw and Burnt Umbers

Black the dominator

Technically speaking, neither black nor white has any colour. However, for the purposes of this book we shall describe them as colours.

Dominator
Black can easily overpower and deaden colours.

A disposable colour?

It is often said that black is unnecessary in an artist's palette as it hardly ever appears at its purest in nature – perhaps black velvet seen on a dull day is the nearest there is. So, is black a colour that could easily be disposed of and omitted from the artist's palette? It is common knowledge that you can readily mix successful deep, solid blacks from the primary colours, and from many of the secondaries too. You can also use these mixtures to darken other colours and tint whites as required.

'White may be said to represent light, without which no colour can be seen; yellow the earth; green, water; blue, air; red, fire; and black, – black is for total darkness.'
Leonardo da Vinci (1452–1519)

Defining black

'Of the colour of jet or carbon, having no hue due to the absorption of nearly all the incident light. Without light, completely dark.'
Collins English Dictionary

Respect black

Black in its own right, however, is a useful and convenient colour, ideal for fluid, spontaneous brush drawing and for attaining a tremendous range of grey tints when mixed with white. It is a colour worth getting to know and has a rightful place in every studio, but its strength and power should never be underestimated. Respect black and handle it with caution.

Black pigment disclosure

These are the references for black pigments, the colouring ingredient of black paint. You will see these in small print on tubes and packaging. Note that the product name, more often than not, is different from the name of the pigment that constitutes the product.

Aniline Black, PBk1 (50440)
Bone Black, PBk9 (77267)
Carbon Black, PBk6/PBk7 (77266)
Synthetic Iron Oxide, PBk11 (77499)

*Note: some listings show Carbon Black as either PBk6 or PBk7

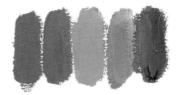

Black as a tinting colour
Creates a multitude of grey tints.

Making black
It is easy to mix black in all media, particularly from the primaries.

Black as a darkener
Creates a multitude of shades.

Naming blacks
You will come across many descriptive names for types of black in books on art and in makers' catalogues and colour charts. Several of the names are old fashioned and may refer to obsolete brands or original, naturally occurring pigment sources that are now manufactured synthetically. Other names are manufacturers' descriptive brand names, often giving different names to what is essentially the same product. Some of the names you may see are:

Animal Black	Kernel Black
Black Lake	Lamp Black
Blue Black	Magnetic
Bone Black	Black
Carbon Black	Marc Black
Coke Black	Mars Black
Deep Black	Mineral Black
Drop Black	Mummy
Elephant	Black
Black	Night Black
Flame Black	Oil Black
Grape Black	Oxide Black
Iron-oxide	Paris Black
Black	Process Black
Ivory Black	Velvet Black
Jet Black	Vine Black

Mars Black
Mars is originally a trade name that has been adopted to prefix earth-colour pigments derived from the mineral iron oxide; Mars was the alchemical name for iron. Among these colours is Mars Black, which is dense and heavy, a pigment that behaves well in oils, but is often recommended as being most desirable for use in watercolour and other water-based media.

Choosing black

Taken at face value black is black, and all blacks look the same. Once you are familiar with the different blacks, however, their subtle and individual characters become evident.

A variety of blacks is offered across the media ranges in oil, watercolour, gouache, acrylic, pastel, etc. When you look in manufacturers' catalogues and at their colour charts you will see many of the descriptive names seen on page 65, particularly in cheaper student and craft colour ranges.

Among the quality blacks are Ivory, Lamp, Vine and Mars Black, and Payne's Grey, or very close relatives to them. These five are generally the most popular. They are offered by most of the major art materials' manufacturers and are widely available in most painting media.

Ivory Black

This is Bone Black sold under the name Ivory Black. As its name suggests, Ivory Black was originally obtained by roasting elephant tusks, a process that produced a pure and intense pigment. Happily, this practice no longer exists, but that is why Ivory Black is also sometimes known as Elephant Black.

Charred bones

At its simplest, Ivory Black is a pigment derived from charred bones. Its predecessors were known as Bone Black and Animal Black and were often impure and unreliable in paint. A finer grade of Bone Black was later developed and manufactured under the name of Ivory Black. It is an intense black pigment, being permanent and stable. Ivory Black has a brown undertone compared to the bluish Lamp Black. In tints with white it tends to produce warmish greys.

Vine Black

Originally made by roasting vine stalks and other vegetable matter at high temperatures (calcining), Vine Black was considered a lower quality pigment to Lamp Black due to its inferior intensity. It was also found to be unreliable for fresco painting where the vegetable content of the pigment would react badly with the minerals of the plaster. Vine Blacks have a bluish undertone and when mixed with whites they produce cool-grey tints.

Lamp Black

This carbon pigment is made from burning oils and collecting the residual soot. Lamp Black is one of the oldest manufactured pigments. It is not quite a pure black, having a slightly bluish colour that is more evident when seen in tints. Lamp Black produces good neutral greys veering slightly to the cool, blue side.

Payne's Grey

Among the blacks in artists' colour charts you will nearly always see this colour listed. Payne's Grey is not a pure black but a composite pigment containing more than one basic ingredient, commonly Ultramarine Blue (sodium polysulphide aluminosilicate) and Mars Black (synthetic iron oxide), and sometimes crimson pigments are included too. It is considered useful by watercolourists as it thins well and is good for glazes. In the opaque media – oil and acrylic – it mixes well with white to produce a range of cool, blue-shade greys. Many purists find such a composite unnecessary.

Experimenting with blacks

There are subtle differences between the various blacks when spread thinly as undertone. You can begin to discern greater differences when the colours are diluted with medium. The differences become even more apparent when mixed with white in tints. The blacks begin to behave differently again when mixed with other colours to produce tints and shades (see page 70).

Payne's Grey
A composite colour commonly made of Lamp Black PBk6, Ultramarine PB29 and powdered slate PBk19. A cool-shade black, producing cool, blue-greys. Ingredients of Payne's Grey vary from manufacturer to manufacturer. (See also Blue Black in some ranges.) *(Sample: Schmincke, Mussini, Resin Oil, PBk7, PB29, PR101)*

Mars Black
Dense, neutral, veering towards cool grey in tints. Widely available in acrylic and composed of PBk11.
(Sample: Old Holland, Classic Artists' Oil, PBk9)

Lamp Black
A very dense opaque black that produces neutral greys in tint.
(Sample: Daler-Rowney, Artists' Oil, PBk7)

Key to colour samples:
(From left to right)
Column 1
Top tone, is paint applied directly from the tube.
Column 2
Undertone, is paint spread fairly thinly.
Column 3
Paint thinned with medium.
Column 4
Paint tinted with Titanium White.

Vine Black
Traditionaly considered inferior in intensity to Lamp Blacks. Vine Blacks have a bluish undertone and when mixed with whites produce cool, bluish grey tints. Vine Black is often a composite of Ivory Black PBk9, Carbon Black PBk7 and Ultramarine PB29 and is commonly available in oil paint.
(Sample: Lukas, Series 1, Artists' Oil, PBk9)

Ivory Black
A dense black, slightly brown in undertone, produced warm glazes and tints. Widely available in oil paint, composed of PBk9.
(Sample: Winsor & Newton, Artists' Oil, PBk9)

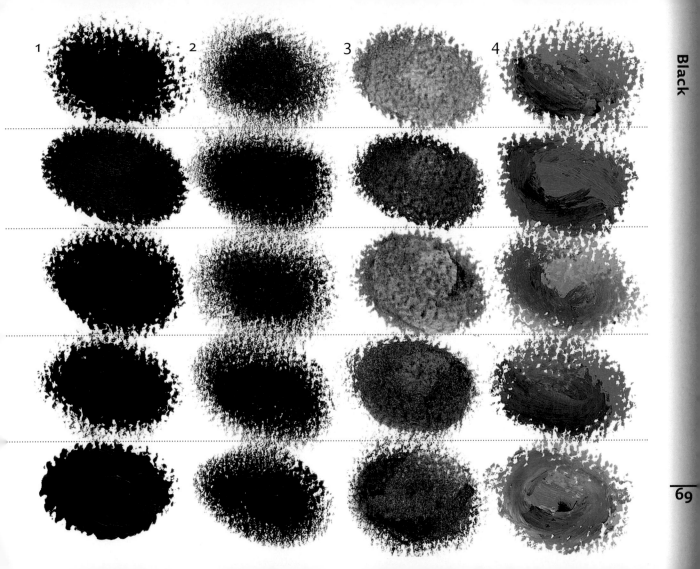

1 2 3 4

Black for tinting and shading

Experiment with the tremendous range of tints and shades to be obtained by mixing blacks with whites and other colours.

Tinting

Variation in the grey tints you achieve will be dictated by the choice of the type of black and white, and, of course, the medium (watercolour, acrylic, gouache, oil). You will notice how some blacks make warm brownish greys and others cool bluish greys, and how some are quite neutral.

Shading

Experiment by mixing blacks with other colours, but be careful! Black used as a darkening ingredient in colour mixes can easily overpower and it will readily obliterate other colours.

Grey scale
A simple grey scale may be made using Ivory Black and opaque white gouache colours. A grey scale is a traditional basic teaching device. Its aim is threefold: to familiarize the student with handling materials, colour mixing and tonal values.

Tone scale
A tone scale also helps to familiarize artists with colour mixing and handling. Here Lemon Yellow and Carbon Black acrylic paints have been used.

Nearly black

Along with Payne's Grey, manufacturers offer many serious, dark colours that at first glance could be mistaken for black. Among these are deep viridians and phthalos, violets, greys, neutral tints and burnt earth colours. When applied thickly these dark colours appear to be nearly black. Add the appropriate diluent (thinner) or medium, however, and the real character of these deep, dark colours becomes apparent.

Bitumen or Asphaltum

This deep-shade brown, which is almost black in top tone, produces warm, earthy neutral tints when mixed with white. It is still available in oil paint from a number of makers.

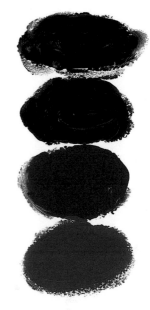

Ground charcoal

To whites and light colours add a little ground charcoal to create the slightly darker colours. Ground charcoal, of course, is a pigment in its own right, identified as PBk8, and is used as an ingredient in paint.

Some deep, dark colours
(From top to bottom)
Phthalo Turquoise, Dioxazine Violet, Virdian, Raw Umber.

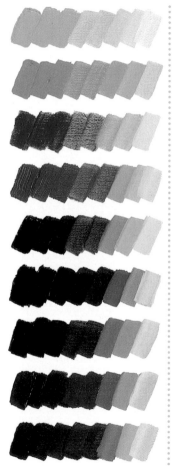

Between black and white

Greys may be produced by mixing black and white in varying proportions, or by mixing complementary colours. Adding red and yellow, or green and blue, produces warm, or cool, greys respectively. In oil painting grey was traditionally obtained by glazing with varnish mixed with a little paint. Greys are also obtained optically by placing small quantities of complementary colours side by side.

Greys are easy to mix and, using reliable pigments, may be more lightfast than some pre-mixed greys. A primary colour mixed with a secondary will provide a wide range of greys and the classic 'palette mud', the remnants of a day's work, provides a good neutral grey that is often reused by the artist.

Greys in history

There are many descriptions of the specific use of grey in the history of painting.

Veneda

An old fresco, greyish black colour, Veneda was made from lime and a suitable black pigment. The term was also used to describe a mix of white lead and black used for tempera on gesso panels or on parchment. Veneda was used in medieval illumination.

Grisaille

This French word is used to describe the technique of painting in several shades of a single colour, usually grey, to build up sculptured relief. The technique is specially suited to architectural subjects. The term also describes underpainting in one colour, specifically grey, to produce a detailed monochromatic painting before colouring over with many layers of glaze. The technique was particularly favoured by the Northern Renaissance artists of Flanders and Germany. Grisaille is also a grey pigment used in stained-glass work.

Guazzo

This grey-in-grey tempera painting was employed by the Old Masters as preliminary exercises for oil painting. It is from the Italian *guazzo* that the French word 'gouache' is derived.

Charcoal Grey

In oils this is ground charcoal. Watercolour is strengthened with carbon black and natural iron oxide. It is lightfast, but often gritty.

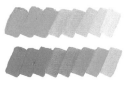

Cool and Warm Greys

Used to describe the particular hue bias. Cool Greys are typically of a green or blue hue, while Warm Greys are of a red or yellow hue.

Graphite Grey

This blue-grey is dense and opaque. A soft, blackish form of crystalline carbon, it was first used in the eighteenth century to make lead pencils. It is named from the Greek *grapho* (meaning 'to write').

Payne's Grey

A blue-grey made from crimson, blue and black or Ultramarine, Ochre and black, the colour is lightfast and inert, but rather coarse. It is thought to have been named from William Payne (1760-1830), a British watercolourist. (See Black, pages 64-71).

Davy's Grey

Originally based on a special variety of powdered slate that tended to be gritty, this is a dull, yellowish grey. The colour is now strengthened and is based on a variety of ingredients - greens, browns, blacks, yellows and whites - but its lightfastness is still not always reliable. Davy's Grey is excellent for toning down mixes. The name was first suggested by Mr Henry Davy in the 1890s.

Naming grey

Greys may bear a descriptive name that gives an indication of their distinguishable hue or bias. Names such as Bluish Grey, Charcoal Grey and Dove Grey. There are also several Neutral Greys that are described as achromatic, having no distinguishable hue. These Neutral Greys are often identified by a numbering system - for example, Neutral Grey 1, Neutral Grey 2 etc. - which indicates the shade.

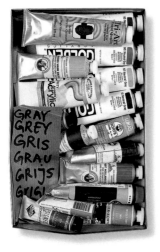

'Forcing yourself to use restricted means is the sort of restraint that liberates invention.'

Pablo Picasso (1881–1973)

Prepared greys

Manufacturers offer several prepared greys. Many are simply composed of two pigments – black (PB) and white (PW), for example. Others are quite complex blends of many pigments.

(From top to bottom, left to right)
Davy's Grey (Winsor & Newton)
Graphite Grey (Tri-Art)
Warm Grey (Talens)
Neutral Grey N3 (Golden)
Warm Grey Light (Old Holland)
Cold Grey (Old Holland)
Warm Grey (Lukas)
Middle Grey (Daler-Rowney)
Neutral Grey N5 (Golden)
Neutral Grey N2 (Golden)
Davy's Grey (Old Holland)
Neutral Grey N7 (Golden)

Blended pigments

Makers offer many greys composed of many pigments. A warm grey could typically comprise white (PW4), green (PG36), yellow ochre (PY42), and brown (PBr33). A cooler grey, such as Payne's Grey, often contains three pigments.

Indispensable white

If black is thought to be unnecessary in an artist's palette, then white is the opposite. It is indispensable to media such as oils, acrylics and gouache. A unique and unmixable colour, it provides the strongest expression of light on the palette. In watercolour the white of the paper performs the function of white pigment, but the versatility of white as a functional colour is well known too. Used as a primer, ground or base coat it is the essential foundation colour on which many a painting is built.

The earliest white

White lead is one of the earliest manufactured pigments on record. It was known in ancient China and is common in the earliest periods of European art. It was the only white oil colour available to artists until the mid nineteenth century and, although new white pigments have come along, it is still popular with oil painters. It has many fine and, some say, unique qualities, producing a buttery paint with great opacity and covering power. It is an excellent mixer that gives fine tones and tints, and is durable and permanent when applied properly following good oil-painting practice.

But, it is poisonous if accidentally ingested, and in many cases has been superseded by less hazardous whites.

White lead stacking in the 19th Century

White lead stacking

The Dutch developed the modern stack process for making white, hence the name Dutch White (PW1). Lead white has been made by the stacking process since Egyptian times.

White pigment was made by placing strips of lead in clay pots with a separate compartment that contained vinegar. The pots were packed tightly together on shelves and interspersed with animal dung to accelerate the chemical process, then sealed in a small outbuilding. A fermentation process took place over about three months, producing carbonate of lead, or lead white pigment. This method of manufacture only ceased in the 1960s.

Chinese White
This is a specially prepared Zinc White and is the traditional watercolour white. It was introduced in 1834 by Winsor & Newton and is now available from many manufacturers. Purist watercolour painters shun the use of Chinese White, claiming the integrity of a watercolour painting relies on the transparency of the medium and the technique of reserving white paper for its unique effect.

'And finds, with keen discriminating sight Black's not so black;- nor white so very white.'
George Canning (1770-1827)

Types of white

Flake White
This is the name you will find in manufacturers' catalogues for white lead (basic lead carbonate PW4). It is available as an oil medium only, as it does not work in other media such as acrylics. It is the traditional choice for the oil painter. Flake White is sometimes offered in two consistencies, one being stiffer. It is a comparatively quick-drying, flexible and durable white. It has two major drawbacks – its toxicity (see page 75) and its tendency to darken if in contact with sulphur, such as may be found in a polluted atmosphere.

Cremnitz White
This is an old-fashioned, high-quality white lead paint made with pure lead carbonate. It is more stringy than Flake White and yellower.

Titanium White
Titanium White is the modern, less hazardous replacement for white lead pigments, particularly for Flake White.

It is a fairly slow dryer as an oil paint and popular as a mixing white. The most powerful of the whites, it is dense and opaque, and should be used with caution as it can overpower more transparent colours. In some catalogues it is suffixed Permanent White. It may be considered a neutral to warm mixer, compared to the cooler Zinc White.

Zinc White
In addition to oils you will find this colour listed with the water-soluble media too, particularly gouaches and acrylics. It is a very versatile white, but is less opaque than the other whites. It is an excellent mixer, particularly for glazing and making tints. In oil paint it is a slow dryer and is said to produce a colder, bluer effect when compared to Flake White. It is manufactured as a watercolour under the name Chinese White.

Mixing White
Some manufacturers offer this colour in their acrylic ranges. It is a good general-purpose white that is excellent for lightening when used in glazes and for

the general toning down of colours. It is quite translucent and mixes well to produce good transparent tints.

Iridescent White

This is composed of a Titanium White type pigment that is coated with mica. It has a pearlized appearance when seen neat. Iridescent White produces effective shimmer colours when used in admixture. Used in thin glazes over colour it produces unique effects of light interference. It is available in oil and acrylic media.

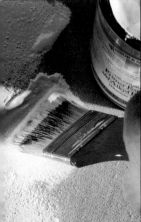

Underpainting White

A general-purpose oil-painting white, this white may be used for preparing grounds and for mixing with other colours. It is quick drying and when used alone produces a matt finish. It should be applied to previously sized or primed canvas.

White used to tint a variety of dark hues

Resists

Resists works on the principle that oil and water do not mix, and white areas can be created by this process. For example, a line drawing can be made with a candle (right) or any greasy medium on a white ground. Subsequent areas of water-based colour may be washed over the initial greasy drawing, which remains as white line.

White magic

White can have a magical influence on the darkest and most sombre of hues (left). By adding white many colours are transformed.

(From top to bottom, left to right)
Indigo (Lukas)
Violet Dioxazine (Tri-Art)
Payne's Grey (Rowney)
Prussian Blue Extra (Old Holland)
Madder Lake Deepest (Lukas)
Vandyke Brown (Winsor & Newton)
Burnt Umber (Winsor & Newton)
Sepia (Lukas)
Vandyke Brown (Lukas)
Viridian Hue (Liquitex)
Phthalo Green Blue Shade (Golden)
Green Earth (Sennelier)

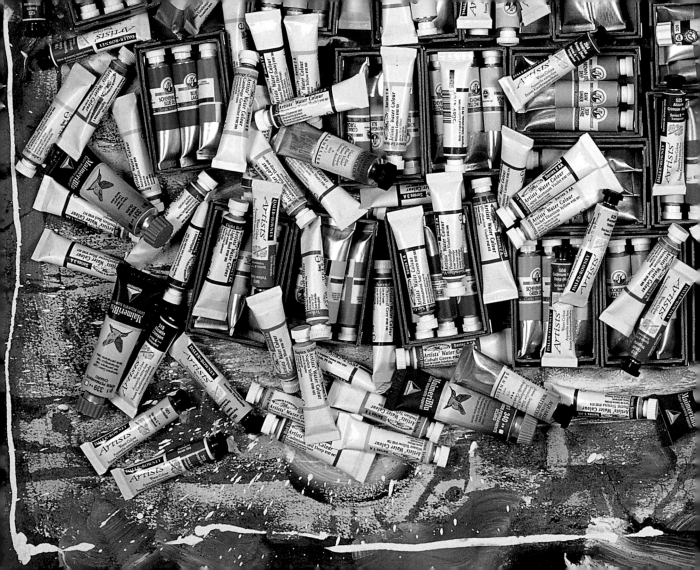

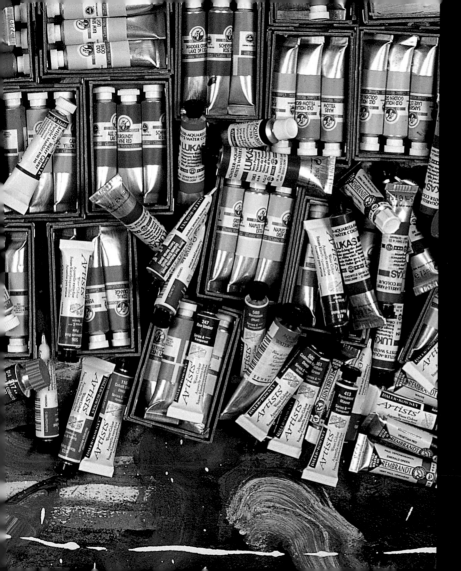

Colour Index

The Colour Index provides a visual reference source of the popular artists' colours, the ones you are most likely to see in the common painting media – oils, watercolour, acrylics and gouache – in the various manufacturers' colour charts. This index is to help you get to know your colours and to demonstrate that, although artists' colours may be given the same name and contain the same basic ingredients, they can vary dramatically in appearance.

Selecting colours

In the making and selecting of colours for the Colour Index the art editors have reviewed and sampled more than 1500 colours from 11 of the world's leading manufacturers. Of the 1500 colours reviewed over 400 have been selected for the index and the following criteria have been applied in the selection.

Colours have been reviewed by name. In certain circumstances you will see the same name repeated in the index – for example, Cadmium Red Deep. The purpose of this is to show how the same-named colour from two, or sometimes more, different manufacturers may vary in hue.

Colours have been reviewed by medium. The Colour Index also provides the opportunity for the reader to see variations in colours of the same name but in different media – for example, how Cadmium Red Deep will look in oil colour, gouache or acrylic.

Colours have been reviewed by pigment. All major manufacturers disclose the pigment content of their colours. It is now quite common to see this information printed on the tube or packaging. Failing this, the pigment declaration can usually be found in the maker's colour chart or catalogue. In the Colour Index you will find colours of the same name that are composed of different pigments or, more importantly for an artist when considering colour, you will see colours with the same pigment content that vary considerably in colour.

Colours have been reviewed by hue. By 'hue' we mean colour or variation of colour (see Colour terminology, page 125). As far as possible within the Colour Index, colours have been grouped – for example, into Neutrals, Reds, Yellows, Blues, Greens, Browns, Earths and Ochres etc. This provides a direct visual comparison and enables you to see the differences between, say, a Cobalt Blue, a Phthalo Blue and an Ultramarine.

Colours have been reviewed for variety. Earlier in the book we looked at the main colour groups and learned something of the history, background, character and handling of various hues. However, it was not possible to show as many colours as we would have liked.

The Colour Index acts as invaluable back-up reference to the earlier section.

Colour behaviour. The Colour Index has used flat colours for sampling and most of the colours have been shown in what is known as top or mass tone. In short this means they have been applied thickly as if seen straight from the tube or sitting as solid blocks in the watercolour pan. The true character of many pigments, particularly at the darker end of the scale, only becomes apparent when diluted or mixed with a medium. In some cases colour samples have been shown applied thickly as top tone and with a touch of white to create a tint to reveal something of the true character of the colour.

Colour accuracy. The only accurate colour charts are hand coloured, and most manufacturers supply these on request. Unfortunately, this book is restricted to the four-colour printing process. While this is a sophisticated and accurate technological process, bear in mind that the colours you see here are not actual pigments but are made up from printing inks (see pages 6–7), so there will be variations between the colours shown and the actual manufacturers' pigment colours.

Yellows – Naples See also Yellow Ochres/Flesh Colours

Naples Yellow 2
PW4/PW6/PY1/PR9/PY42
Rowney Artists' Oil
Naples Yellow 3
PW4/PW6/PY1/PR9/PY42
Rowney Artists' Oil
Naples Yellow Light
PW4/PY35
Talens Van Gogh Oil
Naples Yellow
PBr24/PW6
Winsor & Newton Finity Acrylic

Naples Yellow Light
PW5/PY1/PY42/PR101
Lukas Studio Oil
Naples Yellow Light
PW4/PY42/PY37
Maimeri Classico Oil
Naples Yellow Deep
PW6/PBr24/PY53
Talens Rembrandt Acrylic
Naples Yellow Deep
PW4/PY42/PY37/PO20
Maimeri Artisti Oil

Naples Yellow Extra
PW4/PW6/PY42
Old Holland Classic Oil
Naples Yellow (Hue)
PW6/PY42/PR101
Tri-Art Acrylic
Naples Yellow Deep
PBr24
Winsor & Newton Finity Acrylic
Naples Yellow Deep Extra
PBr24
Old Holland Classic Oil

Yellows – Lemon to Primrose

Cadmium Lemon Yellow
PY37
Maimeri Artisti Oil
Scheveningen Yellow Lemon
PY3
Old Holland Classic Oil
Lemon Yellow Hue
PY53
Winsor & Newton Artists' Oil
Lemon Yellow
PY4/py3/pw6
Sennelier Etude Art Student Oil

Primary Yellow
PY74/PW6
Tri-Art Acrylic
Primary Yellow
PY97
Maimeri Puro Oil
Primary Yellow
PY3
Lukas Studio Oil
Process Yellow
PY74/PY3
Daler-Rowney System 3 Acrylic

Titanate Yellow
PY53
Golden Acrylic
Nickel Titanate Yellow
PY53
Maimeri Artisti Oil
C.P. Cadmium Yellow Primrose
PY35
Golden Acrylic
Rowney Primrose
PY184/PW4
Rowney Artists' Oil

Lemon

Primary

Nickel/Primrose

Yellows – Azo to Cadmium Deep

Azo

Bismuth/ Hansa

Cadmium Deep

Azo Yellow Medium
PY74
Winsor & Newton Finity Acrylic
Yellow Medium Azo
PY74 LF
Liquitex Acrylic
Azo Yellow Medium
PY74
Talens Van Gogh Acrylic
Azo Yellow Deep
PY74/PO43
Talens Van Gogh Acrylic

Bismuth Yellow Medium
PY184
Tri-Art Acrylic
Bismuth Yellow Deep
PY184
Tri-Art Acrylic
Hansa Yellow Light
PY3
Golden Acrylic
Hansa Yellow Medium
PY73
Golden Acrylic

Cadmium Yellow Deep
PO20/PY35
Winsor & Newton Artists' Oil
Cadmium Yellow Deep
PY37
Old Holland Classic Oil
Cadmium Yellow Deep
PO20/PY35
Rowney Artists' Oil
Cadmium Yellow Deep
PO20/PY35
Talens Van Gogh Oil

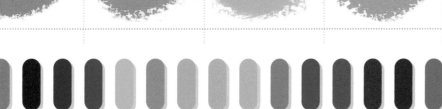

83

Yellows – Cadmium Medium to Brilliant

Cadmium Yellow
PY35
Rowney Artists' Oil
C.P. Cadmium Yellow Medium
PY35
Tri-Art Acrylic
Cadmium Yellow Medium
PY37
Maimeri Artisti Oil
C.P. Cadmium Yellow Medium
PY35
Golden Acrylic

Cadmium Yellow Pale
PY35
Daler-Rowney Cryla Acrylic
Cadmium Yellow Light
PW4/PY1
Lukas Studio Oil
Cadmium Yellow Light
PY35
Golden Acrylic
Cadmium Yellow Light
PY35
Talens Van Gogh Oil

Brilliant Yellow
PY83/PY97/PW6
Maimeri Brera Acrylic
Brilliant Yellow
PY83/PW6/PW4
Sennelier Artists' Oil
Brilliant Yellow Deep
PW4/PY83/PO43
Maimeri Classico Oil
Brilliant Yellow Light
PW4/PW5/PY1
Lukas Studio Oil

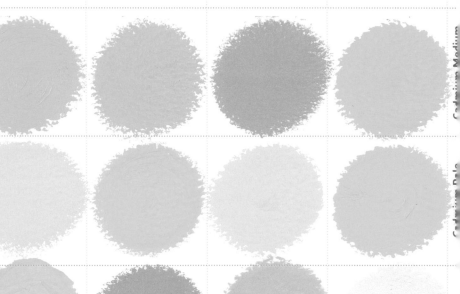

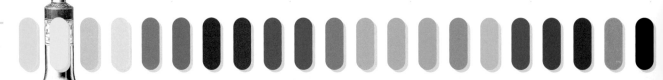

Yellows – Chrome to Indian

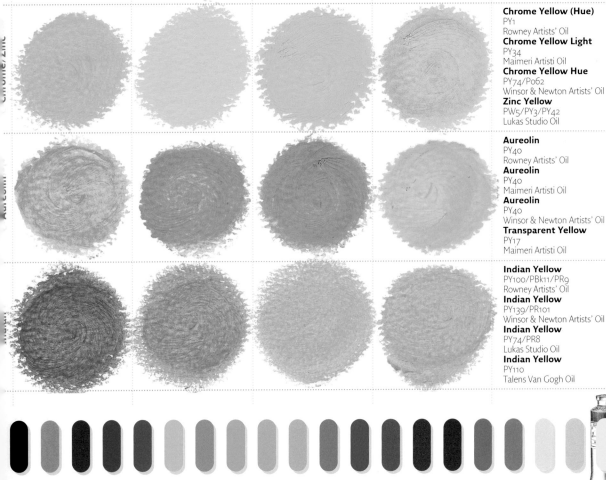

Chrome Yellow (Hue)
PY1
Rowney Artists' Oil
Chrome Yellow Light
PY34
Maimeri Artisti Oil
Chrome Yellow Hue
PY74/Po62
Winsor & Newton Artists' Oil
Zinc Yellow
PW5/PY3/PY42
Lukas Studio Oil

Aureolin
PY40
Rowney Artists' Oil
Aureolin
PY40
Maimeri Artisti Oil
Aureolin
PY40
Winsor & Newton Artists' Oil
Transparent Yellow
PY17
Maimeri Artisti Oil

Indian Yellow
PY100/PBk11/PR9
Rowney Artists' Oil
Indian Yellow
PY139/PR101
Winsor & Newton Artists' Oil
Indian Yellow
PY74/PR8
Lukas Studio Oil
Indian Yellow
PY110
Talens Van Gogh Oil

Yellows – Indian to Ochre See also Earths and Ochres

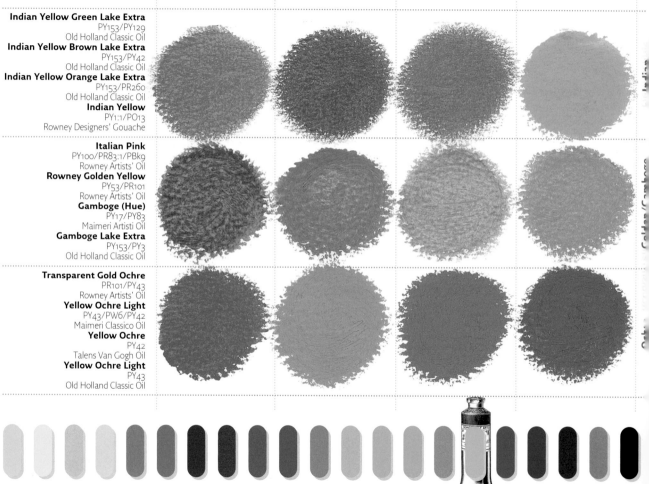

Indian Yellow Green Lake Extra
PY153/PY129
Old Holland Classic Oil

Indian Yellow Brown Lake Extra
PY153/PY42
Old Holland Classic Oil

Indian Yellow Orange Lake Extra
PY153/PR260
Old Holland Classic Oil

Indian Yellow
PY1:1/PO13
Rowney Designers' Gouache

Italian Pink
PY100/PR83:1/PBk9
Rowney Artists' Oil

Rowney Golden Yellow
PY53/PR101
Rowney Artists' Oil

Gamboge (Hue)
PY17/PY83
Maimeri Artisti Oil

Gamboge Lake Extra
PY153/PY3
Old Holland Classic Oil

Transparent Gold Ochre
PR101/PY43
Rowney Artists' Oil

Yellow Ochre Light
PY43/PW6/PY42
Maimeri Classico Oil

Yellow Ochre
PY42
Talens Van Gogh Oil

Yellow Ochre Light
PY43
Old Holland Classic Oil

Reddish Yellows – Flesh Ochre to Sandstone

Flesh Ochre
PY42/PR188/PR102
Old Holland Classic Oil
Flesh Ochre
in Titanium White tint
Naples Yellow Reddish
PW5/PY3/PY42/PO34
Lukas Studio Oil
Naples Yellow Reddish
in Titanium White tint

Naples Yellow Red
PW4/PY35/PR108
Talens Van Gogh Oil
Naples Yellow Reddish Extra
PW4/PW6/PY53/PO43/PR260
Old Holland Classic Oil
Naples Yellow Reddish
PW4/PW6/PO43
Maimeri Classico Oil
Naples Yellow Reddish
PW4/PY37/PR108
Maimeri Artisti Oil

Brilliant Yellow Reddish
PW4/PW6/PY53/PO69/PO43
Old Holland Classic Oil
Brilliant Yellow Light
PW4/PW6/PY83/PO69
Old Holland Classic Oil
Jaune Brillant
PY138/PY42/PR188/PW6
Winsor & Newton Artists' Oil
Sandstone
PR101/PY1:1/PW6
Daler-Rowney Designers' Gouache

Oranges – Yellowish Oranges to Reddish Oranges

Helio Genuine Yellow Deep
PO62/PO34/PY1
Lukas Sorte 1 Oil
Tangerine
PR4
Daler-Rowney Designers' Gouache
Benzimidazolone Orange
PO62
Winsor & Newton Finity Acrylic
Azo Orange
PY74/PO34
Talens Van Gogh Acrylic

Cadmium Orange
PO20
Schmincke Horadam Gouache
C.P. Cadmium Orange
PO20
Golden Acrylic
Cadmium Orange
PO20
Old Holland Classic Oil
Naphthol Orange
PY65/PR112
Tri-Art Acrylic

Helio Genuine Orange
PO62/PO13
Lukas Sorte 1 Oil
Pyrrole Orange
PO73
Tri-Art Acrylic
Chrome Orange
PW5/PO36
Lukas Studio Oil
Chrome Orange Deep (Hue)
PO34/PY74/PY42
Daler-Rowney Georgian Oil

Reds – Coral to Scarlet

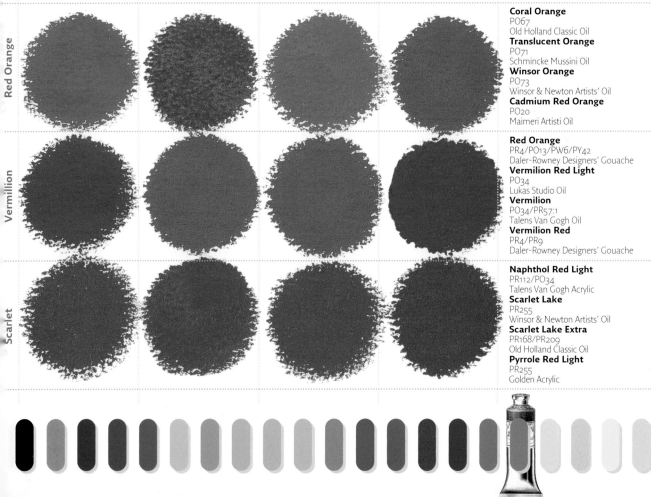

Red Orange

Coral Orange
PO67
Old Holland Classic Oil
Translucent Orange
PO71
Schmincke Mussini Oil
Winsor Orange
PO73
Winsor & Newton Artists' Oil
Cadmium Red Orange
PO20
Maimeri Artisti Oil

Vermillion

Red Orange
PR4/PO13/PW6/PY42
Daler-Rowney Designers' Gouache
Vermilion Red Light
PO34
Lukas Studio Oil
Vermilion
PO34/PR57:1
Talens Van Gogh Oil
Vermilion Red
PR4/PR9
Daler-Rowney Designers' Gouache

Scarlet

Naphthol Red Light
PR112/PO34
Talens Van Gogh Acrylic
Scarlet Lake
PR255
Winsor & Newton Artists' Oil
Scarlet Lake Extra
PR168/PR209
Old Holland Classic Oil
Pyrrole Red Light
PR255
Golden Acrylic

Reds – Cadmium Light to Pyrrole Medium

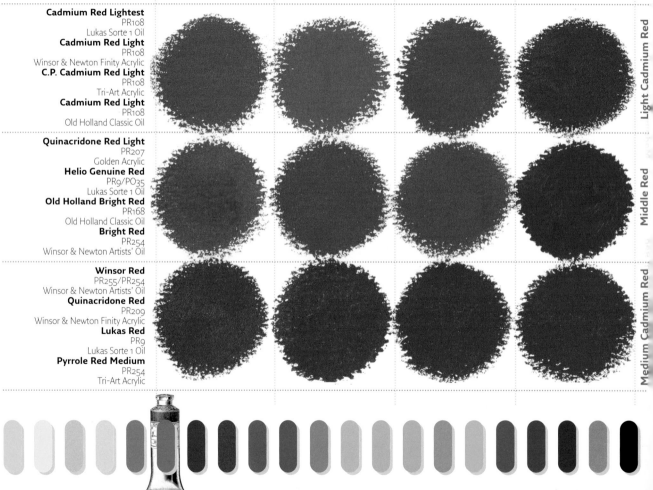

Cadmium Red Lightest
PR108
Lukas Sorte 1 Oil
Cadmium Red Light
PR108
Winsor & Newton Finity Acrylic
C.P. Cadmium Red Light
PR108
Tri-Art Acrylic
Cadmium Red Light
PR108
Old Holland Classic Oil

Quinacridone Red Light
PR207
Golden Acrylic
Helio Genuine Red
PR9/PO35
Lukas Sorte 1 Oil
Old Holland Bright Red
PR168
Old Holland Classic Oil
Bright Red
PR254
Winsor & Newton Artists' Oil

Winsor Red
PR255/PR254
Winsor & Newton Artists' Oil
Quinacridone Red
PR209
Winsor & Newton Finity Acrylic
Lukas Red
PR9
Lukas Sorte 1 Oil
Pyrrole Red Medium
PR254
Tri-Art Acrylic

Light Cadmium Red

Middle Red

Medium Cadmium Red

Reds – Medium Cadmium to Deep Cadmium

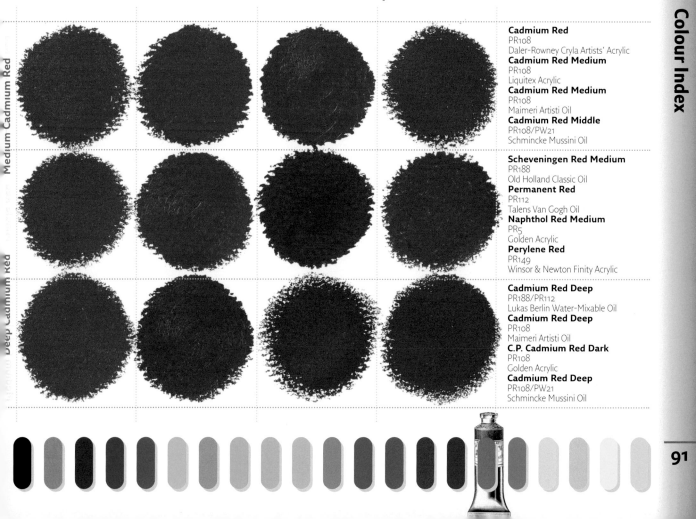

Medium Cadmium Red

Cadmium Red
PR108
Daler-Rowney Cryla Artists' Acrylic
Cadmium Red Medium
PR108
Liquitex Acrylic
Cadmium Red Medium
PR108
Maimeri Artisti Oil
Cadmium Red Middle
PR108/PW21
Schmincke Mussini Oil

Deep Cadmium Red

Scheveningen Red Medium
PR188
Old Holland Classic Oil
Permanent Red
PR112
Talens Van Gogh Oil
Naphthol Red Medium
PR5
Golden Acrylic
Perylene Red
PR149
Winsor & Newton Finity Acrylic

Cadmium Red Deep
PR188/PR112
Lukas Berlin Water-Mixable Oil
Cadmium Red Deep
PR108
Maimeri Artisti Oil
C.P. Cadmium Red Dark
PR108
Golden Acrylic
Cadmium Red Deep
PR108/PW21
Schmincke Mussini Oil

Reds – Vermillion to Alizarin

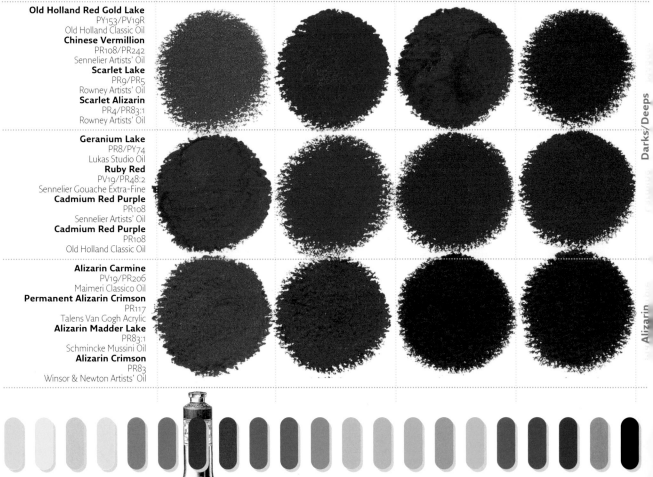

Old Holland Red Gold Lake
PY153/PV19R
Old Holland Classic Oil
Chinese Vermillion
PR108/PR242
Sennelier Artists' Oil
Scarlet Lake
PR9/PR5
Rowney Artists' Oil
Scarlet Alizarin
PR4/PR83:1
Rowney Artists' Oil

Geranium Lake
PR8/PY74
Lukas Studio Oil
Ruby Red
PV19/PR48:2
Sennelier Gouache Extra-Fine
Cadmium Red Purple
PR108
Sennelier Artists' Oil
Cadmium Red Purple
PR108
Old Holland Classic Oil

Alizarin Carmine
PV19/PR206
Maimeri Classico Oil
Permanent Alizarin Crimson
PR117
Talens Van Gogh Acrylic
Alizarin Madder Lake
PR83:1
Schmincke Mussini Oil
Alizarin Crimson
PR83
Winsor & Newton Artists' Oil

Darks/Deeps

Alizarin

Rens – Madder to Purple

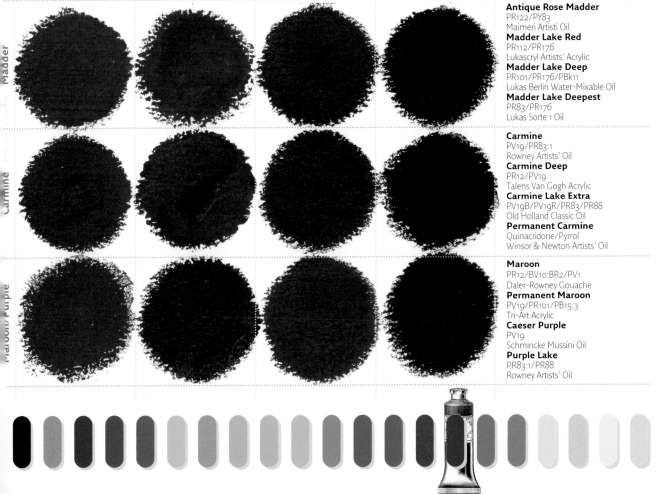

Antique Rose Madder
PR122/PY83
Maimeri Artisti Oil
Madder Lake Red
PR112/PR176
Lukascryl Artists' Acrylic
Madder Lake Deep
PR101/PR176/PBk11
Lukas Berlin Water-Mixable Oil
Madder Lake Deepest
PR83/PR176
Lukas Sorte 1 Oil

Carmine
PV19/PR83:1
Rowney Artists' Oil
Carmine Deep
PR12/PV19
Talens Van Gogh Acrylic
Carmine Lake Extra
PV19B/PV19R/PR83/PR88
Old Holland Classic Oil
Permanent Carmine
Quinacridone/Pyrrol
Winsor & Newton Artists' Oil

Maroon
PR12/BV10:BR2/PV1
Daler-Rowney Gouache
Permanent Maroon
PV19/PR101/PB15:3
Tri-Art Acrylic
Caeser Purple
PV19
Schmincke Mussini Oil
Purple Lake
PR83:1/PR88
Rowney Artists' Oil

Reds – Deep Pink to Brilliant Rose

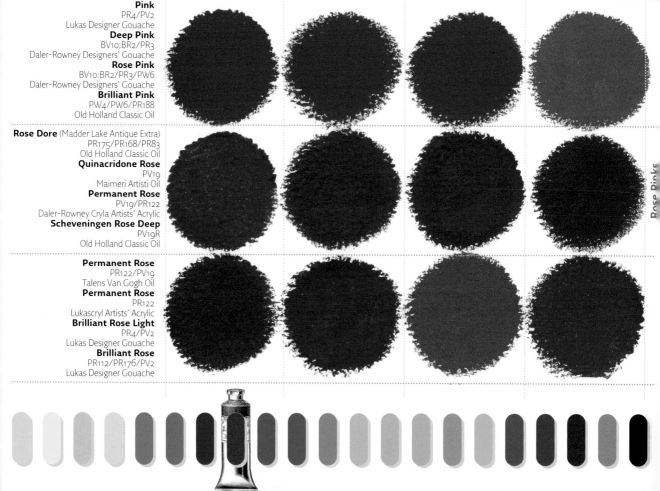

Pink
PR4/PV2
Lukas Designer Gouache

Deep Pink
BV10:BR2/PR3
Daler-Rowney Designers' Gouache

Rose Pink
BV10:BR2/PR3/PW6
Daler-Rowney Designers' Gouache

Brilliant Pink
PW4/PW6/PR188
Old Holland Classic Oil

Rose Dore (Madder Lake Antique Extra)
PR175/PR168/PR83
Old Holland Classic Oil

Quinacridone Rose
PV19
Maimeri Artisti Oil

Permanent Rose
PV19/PR122
Daler-Rowney Cryla Artists' Acrylic

Scheveningen Rose Deep
PV19R
Old Holland Classic Oil

Permanent Rose
PR122/PV19
Talens Van Gogh Oil

Permanent Rose
PR122
Lukascryl Artists' Acrylic

Brilliant Rose Light
PR4/PV2
Lukas Designer Gouache

Brilliant Rose
PR112/PR176/PV2
Lukas Designer Gouache

Rose Pinks

Reds – Magenta Shades

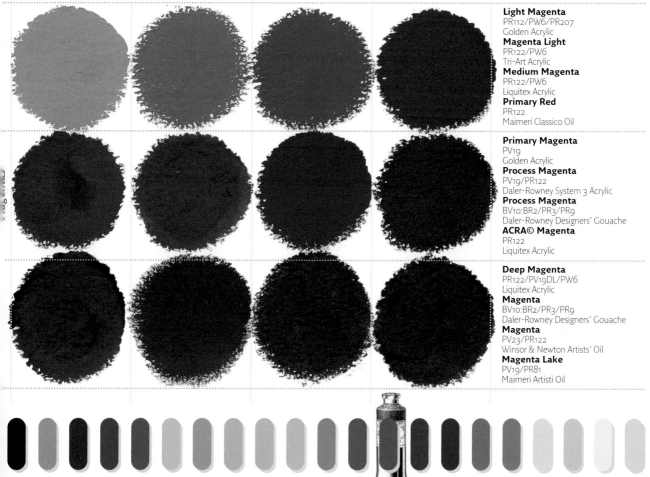

Light Magenta
PR112/PW6/PR207
Golden Acrylic
Magenta Light
PR122/PW6
Tri-Art Acrylic
Medium Magenta
PR122/PW6
Liquitex Acrylic
Primary Red
PR122
Maimeri Classico Oil

Primary Magenta
PV19
Golden Acrylic
Process Magenta
PV19/PR122
Daler-Rowney System 3 Acrylic
Process Magenta
BV10:BR2/PR3/PR9
Daler-Rowney Designers' Gouache
ACRA© Magenta
PR122
Liquitex Acrylic

Deep Magenta
PR122/PV19DL/PW6
Liquitex Acrylic
Magenta
BV10:BR2/PR3/PR9
Daler-Rowney Designers' Gouache
Magenta
PV23/PR122
Winsor & Newton Artists' Oil
Magenta Lake
PV19/PR81
Maimeri Artisti Oil

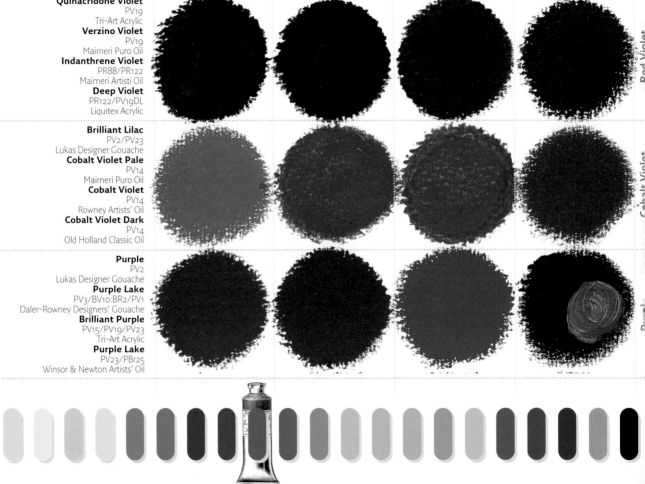

☛ **Note**
Dark pigments are also shown with a white tint detail
to bring out the true character of the colours.

Colour Index

Quinacridone Violet
PV19
Tri-Art Acrylic
Verzino Violet
PV19
Maimeri Puro Oil
Indanthrene Violet
PR88/PR122
Maimeri Artisti Oil
Deep Violet
PR122/PV19DL
Liquitex Acrylic

Brilliant Lilac
PV2/PV23
Lukas Designer Gouache
Cobalt Violet Pale
PV14
Maimeri Puro Oil
Cobalt Violet
PV14
Rowney Artists' Oil
Cobalt Violet Dark
PV14
Old Holland Classic Oil

Purple
PV2
Lukas Designer Gouache
Purple Lake
PV3/BV10:BR2/PV1
Daler-Rowney Designers' Gouache
Brilliant Purple
PV15/PV19/PV23
Tri-Art Acrylic
Purple Lake
PV23/PBr25
Winsor & Newton Artists' Oil

Violets – Manganese to Ultramarine

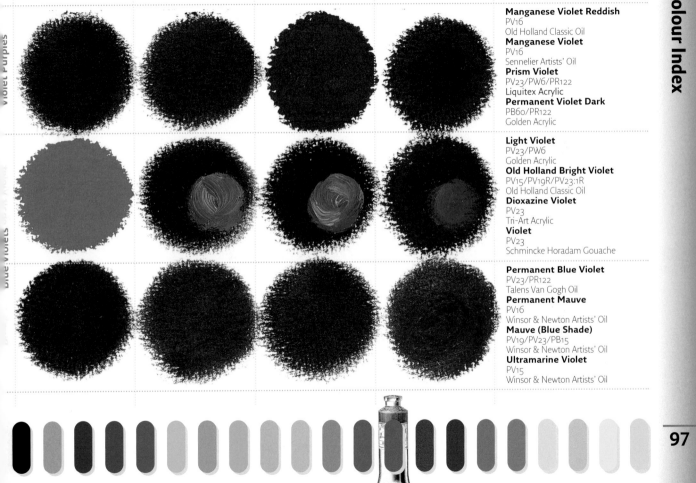

Manganese Violet Reddish
PV16
Old Holland Classic Oil
Manganese Violet
PV16
Sennelier Artists' Oil
Prism Violet
PV23/PW6/PR122
Liquitex Acrylic
Permanent Violet Dark
PB60/PR122
Golden Acrylic

Light Violet
PV23/PW6
Golden Acrylic
Old Holland Bright Violet
PV15/PV19R/PV23:1R
Old Holland Classic Oil
Dioxazine Violet
PV23
Tri-Art Acrylic
Violet
PV23
Schmincke Horadam Gouache

Permanent Blue Violet
PV23/PR122
Talens Van Gogh Oil
Permanent Mauve
PV16
Winsor & Newton Artists' Oil
Mauve (Blue Shade)
PV19/PV23/PB15
Winsor & Newton Artists' Oil
Ultramarine Violet
PV15
Winsor & Newton Artists' Oil

Blues – Blue Violet to Prussian

☛Note
Dark pigments are also shown with a white tint detail
to bring out the true character of the colours.

Old Holland Blue Violet
PB15:1/PV23:1R
Old Holland Classic Oil
Faience Blue
PB60
Maimeri Puro Oil
Indanthrene Blue
PB60
Daler-Rowney Cryla Artists' Acrylic
Old Holland Blue Deep
PB29/PB60/PBk7
Old Holland Classic Oil

Indigo
PG7/PBk7/PB29
Rowney Artists' Oil
Paris Blue
PB27
Lukas Studio Oil
Prussian Blue
PB27
Rowney Artists' Oil
Prussian Blue
PB27
Liquitex Acrylic

Prussian Blue (Hue)
PB15:1/PV23
Tri-Art Acrylic
Prussian Blue Phthalo
PB15:4/PBk11
Talens Van Gogh Acrylic
Old Holland Blue
PB15
Old Holland Classic Oil
Winsor Blue (Red Shade)
PB15
Winsor & Newton Artists' Oil

Violet Blues/Deep Blues

Indigo/Prussian

Prussians/Red shades

Blues – Phthalo to French Ultramarine

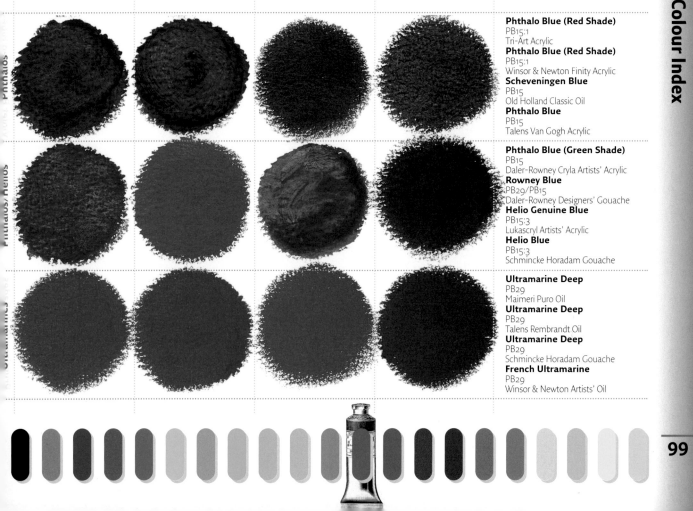

Phthalo Blue (Red Shade)
PB15:1
Tri-Art Acrylic
Phthalo Blue (Red Shade)
PB15:1
Winsor & Newton Finity Acrylic
Scheveningen Blue
PB15
Old Holland Classic Oil
Phthalo Blue
PB15
Talens Van Gogh Acrylic

Phthalo Blue (Green Shade)
PB15
Daler-Rowney Cryla Artists' Acrylic
Rowney Blue
PB29/PB15
Daler-Rowney Designers' Gouache
Helio Genuine Blue
PB15:3
Lukascryl Artists' Acrylic
Helio Blue
PB15:3
Schmincke Horadam Gouache

Ultramarine Deep
PB29
Maimeri Puro Oil
Ultramarine Deep
PB29
Talens Rembrandt Oil
Ultramarine Deep
PB29
Schmincke Horadam Gouache
French Ultramarine
PB29
Winsor & Newton Artists' Oil

Blues – Ultramarine to Cobalt

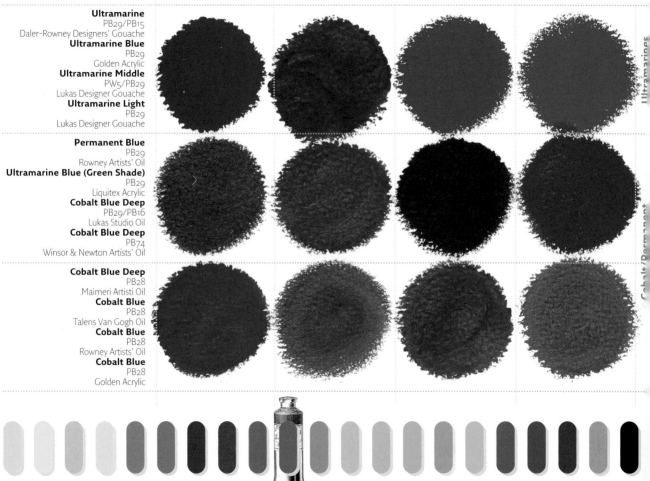

Ultramarine
PB29/PB15
Daler-Rowney Designers' Gouache
Ultramarine Blue
PB29
Golden Acrylic
Ultramarine Middle
PW5/PB29
Lukas Designer Gouache
Ultramarine Light
PB29
Lukas Designer Gouache

Permanent Blue
PB29
Rowney Artists' Oil
Ultramarine Blue (Green Shade)
PB29
Liquitex Acrylic
Cobalt Blue Deep
PB29/PB16
Lukas Studio Oil
Cobalt Blue Deep
PB74
Winsor & Newton Artists' Oil

Cobalt Blue Deep
PB28
Maimeri Artisti Oil
Cobalt Blue
PB28
Talens Van Gogh Oil
Cobalt Blue
PB28
Rowney Artists' Oil
Cobalt Blue
PB28
Golden Acrylic

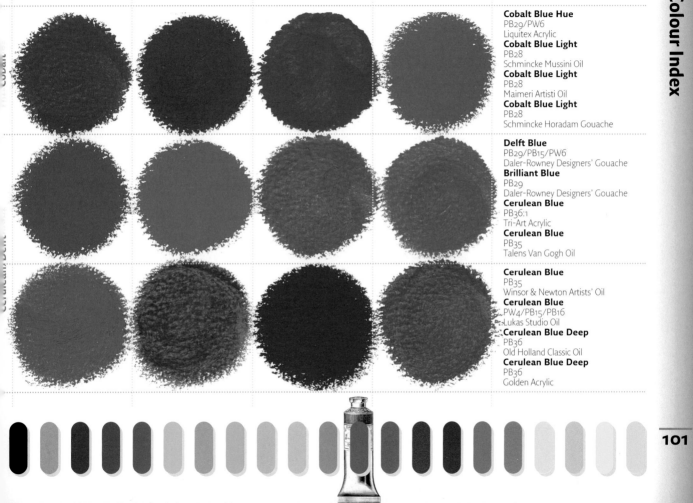

Cobalt Blue Hue
PB29/PW6
Liquitex Acrylic
Cobalt Blue Light
PB28
Schmincke Mussini Oil
Cobalt Blue Light
PB28
Maimeri Artisti Oil
Cobalt Blue Light
PB28
Schmincke Horadam Gouache

Delft Blue
PB29/PB15/PW6
Daler-Rowney Designers' Gouache
Brilliant Blue
PB29
Daler-Rowney Designers' Gouache
Cerulean Blue
PB36:1
Tri-Art Acrylic
Cerulean Blue
PB35
Talens Van Gogh Oil

Cerulean Blue
PB35
Winsor & Newton Artists' Oil
Cerulean Blue
PW4/PB15/PB16
Lukas Studio Oil
Cerulean Blue Deep
PB36
Old Holland Classic Oil
Cerulean Blue Deep
PB36
Golden Acrylic

Blues – Manganese to Primary

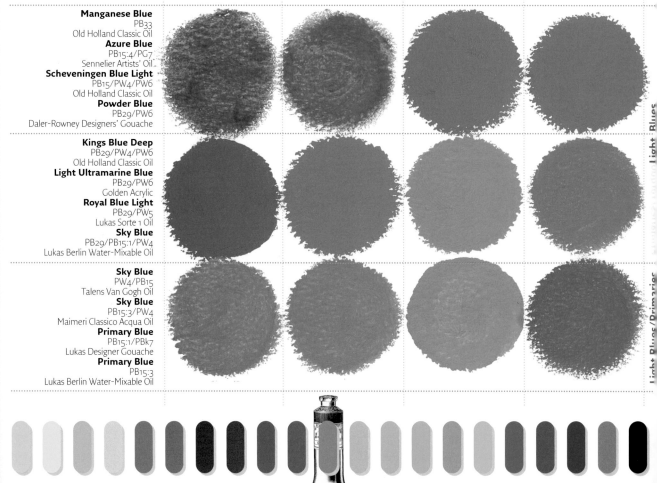

Manganese Blue
PB33
Old Holland Classic Oil

Azure Blue
PB15:4/PG7
Sennelier Artists' Oil

Scheveningen Blue Light
PB15/PW4/PW6
Old Holland Classic Oil

Powder Blue
PB29/PW6
Daler-Rowney Designers' Gouache

Kings Blue Deep
PB29/PW4/PW6
Old Holland Classic Oil

Light Ultramarine Blue
PB29/PW6
Golden Acrylic

Royal Blue Light
PB29/PW5
Lukas Sorte 1 Oil

Sky Blue
PB29/PB15:1/PW4
Lukas Berlin Water-Mixable Oil

Sky Blue
PW4/PB15
Talens Van Gogh Oil

Sky Blue
PB15:3/PW4
Maimeri Classico Acqua Oil

Primary Blue
PB15:1/PBk7
Lukas Designer Gouache

Primary Blue
PB15:3
Lukas Berlin Water-Mixable Oil

Light Blues

Light Blues/Primaries

Blues – Primary to Turquoise

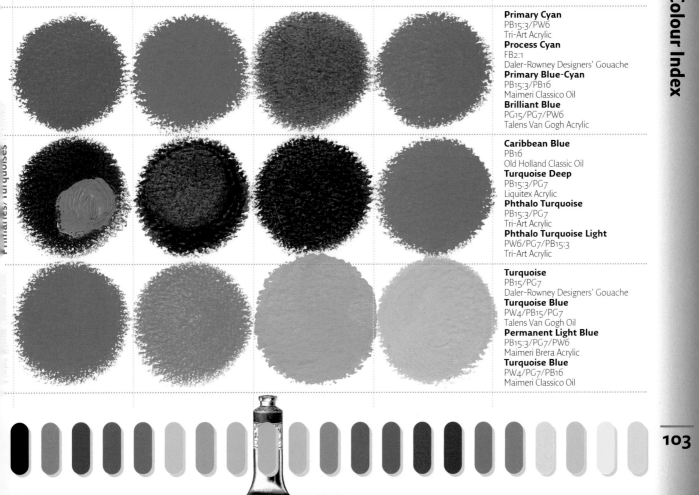

Primary Cyan
PB15:3/PW6
Tri-Art Acrylic
Process Cyan
FB2:1
Daler-Rowney Designers' Gouache
Primary Blue-Cyan
PB15:3/PB16
Maimeri Classico Oil
Brilliant Blue
PG15/PG7/PW6
Talens Van Gogh Acrylic

Caribbean Blue
PB16
Old Holland Classic Oil
Turquoise Deep
PB15:3/PG7
Liquitex Acrylic
Phthalo Turquoise
PB15:3/PG7
Tri-Art Acrylic
Phthalo Turquoise Light
PW6/PG7/PB15:3
Tri-Art Acrylic

Turquoise
PB15/PG7
Daler-Rowney Designers' Gouache
Turquoise Blue
PW4/PB15/PG7
Talens Van Gogh Oil
Permanent Light Blue
PB15:3/PG7/PW6
Maimeri Brera Acrylic
Turquoise Blue
PW4/PG7/PB16
Maimeri Classico Oil

Blue/greens – Turquoise to Emerald

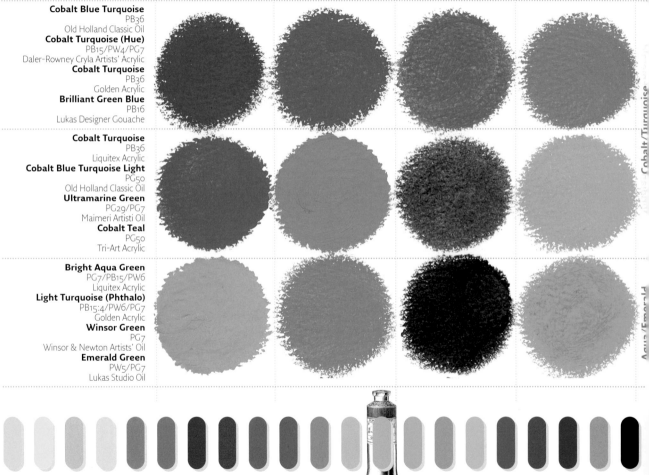

Cobalt Blue Turquoise
PB36
Old Holland Classic Oil
Cobalt Turquoise (Hue)
PB15/PW4/PG7
Daler-Rowney Cryla Artists' Acrylic
Cobalt Turquoise
PB36
Golden Acrylic
Brilliant Green Blue
PB16
Lukas Designer Gouache

Cobalt Turquoise
PB36
Liquitex Acrylic
Cobalt Blue Turquoise Light
PG50
Old Holland Classic Oil
Ultramarine Green
PG29/PG7
Maimeri Artisti Oil
Cobalt Teal
PG50
Tri-Art Acrylic

Bright Aqua Green
PG7/PB15/PW6
Liquitex Acrylic
Light Turquoise (Phthalo)
PB15:4/PW6/PG7
Golden Acrylic
Winsor Green
PG7
Winsor & Newton Artists' Oil
Emerald Green
PW5/PG7
Lukas Studio Oil

Cobalt/Turquoise

Aqua/Emerald

Greens – Emerald to Cobalt

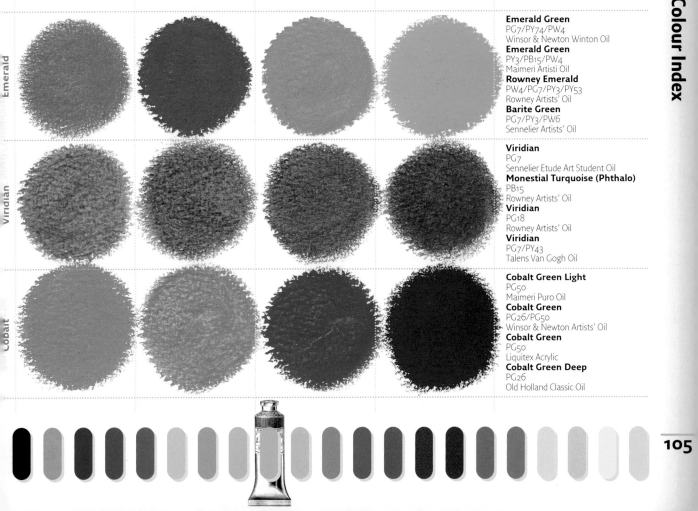

Emerald Green
PG7/PY74/PW4
Winsor & Newton Winton Oil
Emerald Green
PY3/PB15/PW4
Maimeri Artisti Oil
Rowney Emerald
PW4/PG7/PY3/PY53
Rowney Artists' Oil
Barite Green
PG7/PY3/PW6
Sennelier Artists' Oil

Viridian
PG7
Sennelier Etude Art Student Oil
Monestial Turquoise (Phthalo)
PB15
Rowney Artists' Oil
Viridian
PG18
Rowney Artists' Oil
Viridian
PG7/PY43
Talens Van Gogh Oil

Cobalt Green Light
PG50
Maimeri Puro Oil
Cobalt Green
PG26/PG50
Winsor & Newton Artists' Oil
Cobalt Green
PG50
Liquitex Acrylic
Cobalt Green Deep
PG26
Old Holland Classic Oil

Emerald

Viridian

Cobalt

Greens – Brilliant to Cadmium

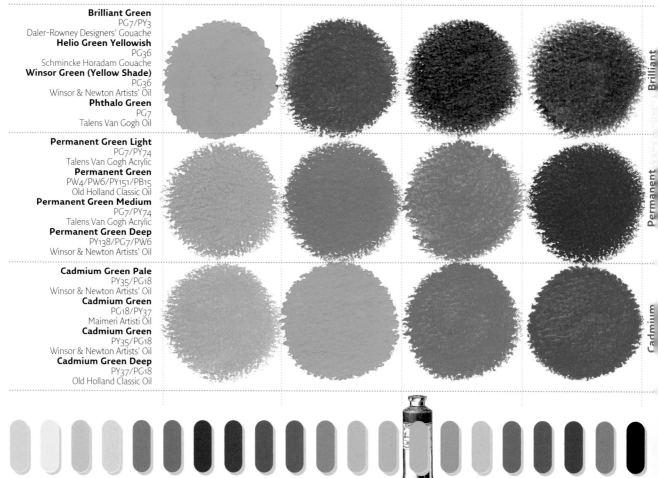

Brilliant Green
PG7/PY3
Daler-Rowney Designers' Gouache
Helio Green Yellowish
PG36
Schmincke Horadam Gouache
Winsor Green (Yellow Shade)
PG36
Winsor & Newton Artists' Oil
Phthalo Green
PG7
Talens Van Gogh Oil

Permanent Green Light
PG7/PY74
Talens Van Gogh Acrylic
Permanent Green
PW4/PW6/PY151/PB15
Old Holland Classic Oil
Permanent Green Medium
PG7/PY74
Talens Van Gogh Acrylic
Permanent Green Deep
PY138/PG7/PW6
Winsor & Newton Artists' Oil

Cadmium Green Pale
PY35/PG18
Winsor & Newton Artists' Oil
Cadmium Green
PG18/PY37
Maimeri Artisti Oil
Cadmium Green
PY35/PG18
Winsor & Newton Artists' Oil
Cadmium Green Deep
PY37/PG18
Old Holland Classic Oil

Brilliant

Permanent

Cadmium

Greens – Saffron to Cinnabar

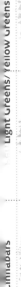

Saffron Green
PG7/PY3
Daler-Rowney Designers' Gouache
Vivid Lime Green
PY97/PG7/PW6
Liquitex Acrylic
Bright Green
PG7/PY3
Daler-Rowney Cryla Artists' Acrylic
Light Green (Yellow Shade)
PG7/PY3/PW6
Golden Acrylic

Light Green
PG7/PY3
Daler-Rowney Designers' Gouache
Yellow Green
PG7/PY3/PW6/PY42
Daler-Rowney Designers' Gouache
Yellowish Green
PG7/PY74/PW4
Talens Van Gogh Oil
Yellowish Green
PG7/PY74
Talens Rembrandt Acrylic

Cinnabar Green Lightest
PY1/PG7
Lukas Designer Gouache
Cinnabar Green Light Extra
PY35/PG18/PB29
Old Holland Classic Oil
Cinnabar Green Light
PY1/PB15
Maimeri Artisti Oil
Cinnabar Green Deep
PY1/PB16
Lukas Designer Gouache

Light Greens/Yellow Greens

Cinnabars

Greens – Chrome Oxide to Holland Green

☞ Note
Dark pigments are also shown with a white tint detail to bring out the true character of the colours.

Colour Index

Opaque Oxide of Chromium
PG17
Daler-Rowney Designers' Gouache
Chrome Oxide Green
PG17
Maimeri Puro Oil
Chromium Oxide Green
PG17
Liquitex Acrylic
Chrome Green Deep Hue
PB15/PG7/PY42
Winsor & Newton Artists' Oil

Sap Green Light
PY42/PG7
Tri-Art Acrylic
Sap Green
PB60/PY150
Schmincke Mussini Oil
Hooker's Green No. 2
PY3/PR101/PG7
Rowney Artists' Oil
Hooker's Green Lake Deep Extra
PR101/PG7/PBk7
Old Holland Classic Oil

Stil De Grain Yellow
PY1/PG10
Maimeri Artisti Oil
Green Gold
PY150/PG36/PY3
Golden Acrylic
Old Holland Golden Green
PY129
Old Holland Classic Oil
Old Holland Green Deep
PY129/PG36
Old Holland Classic Oil

Oxides

San/Hooker's

Golden

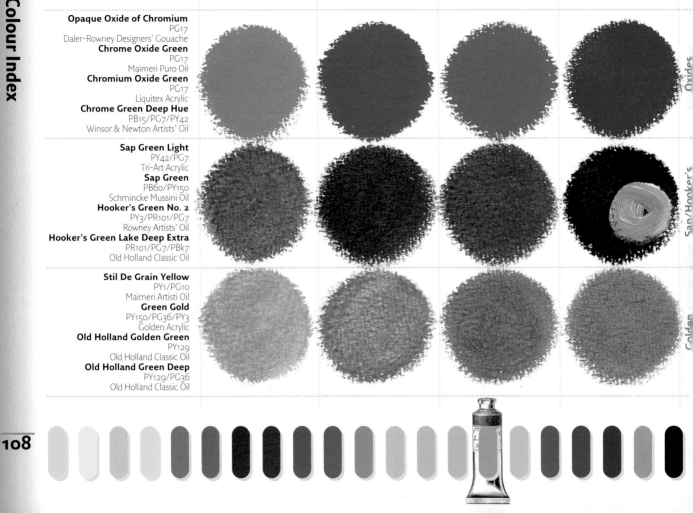

108

Greens – Green Earth to Green Umber

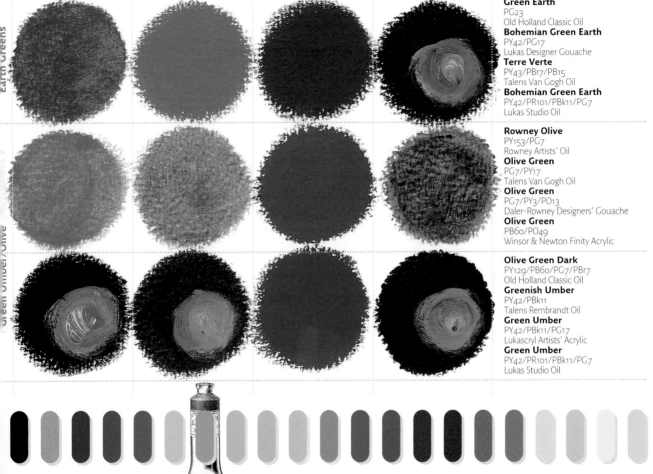

Earth Greens

Green Umber/Olive

Green Earth
PG23
Old Holland Classic Oil
Bohemian Green Earth
PY42/PG17
Lukas Designer Gouache
Terre Verte
PY43/PBr7/PB15
Talens Van Gogh Oil
Bohemian Green Earth
PY42/PR101/PBk11/PG7
Lukas Studio Oil

Rowney Olive
PY153/PG7
Rowney Artists' Oil
Olive Green
PG7/PY17
Talens Van Gogh Oil
Olive Green
PG7/PY3/PO13
Daler-Rowney Designers' Gouache
Olive Green
PB60/PO49
Winsor & Newton Finity Acrylic

Olive Green Dark
PY129/PB60/PG7/PBr7
Old Holland Classic Oil
Greenish Umber
PY42/PBk11
Talens Rembrandt Oil
Green Umber
PY42/PBk11/PG17
Lukascryl Artists' Acrylic
Green Umber
PY42/PR101/PBk11/PG7
Lukas Studio Oil

Earths – Yellow Ochre to Golden Ochre

Yellow Ochre
PY43
Winsor & Newton Artists' Oil
Yellow Ochre
PY43
Winsor & Newton Finity Acrylic
Yellow Ochre
PY43/PW4/PY42
Maimeri Classico Oil
Yellow Ochre
PY42
Talens Van Gogh Acrylic

Yellow Ochre Light
PY42
Lukas Studio Oil
Attish Light Ochre
PY42
Schmincke Mussini Oil
Yellow Ochre Pale
PY43/PW4
Maimeri Artisti Oil
Yellow Ochre Light
PBr24
Talens Van Gogh Acrylic

Gold Ochre
PY43
Old Holland Classic Oil
Gold Ochre
PY42/PR101/PBk11
Lukas Studio Oil
Gold Ochre
PY42
Winsor & Newton Finity Acrylic
Golden Ochre
PY53/PR101
Daler-Rowney Cryla Acrylic

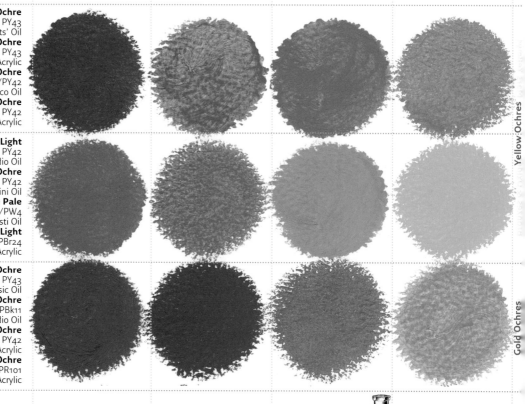

Yellow Ochres

Gold Ochres

Earths – Mars Yellow to Raw Sienna

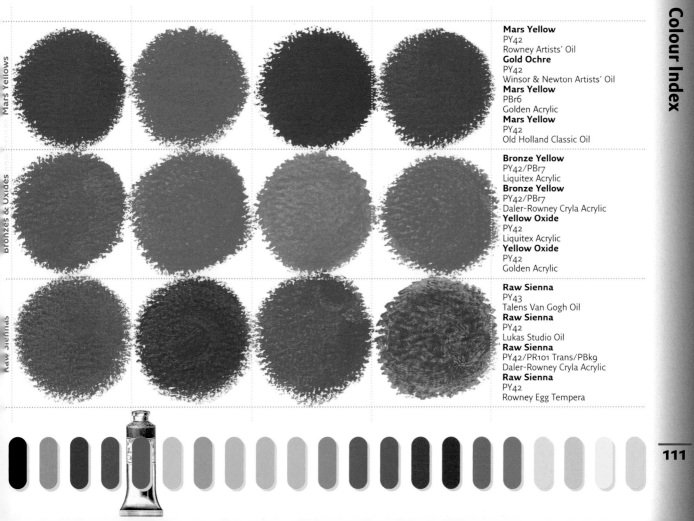

Mars Yellows

Bronzes & Oxides

Raw Siennas

Mars Yellow
PY42
Rowney Artists' Oil
Gold Ochre
PY42
Winsor & Newton Artists' Oil
Mars Yellow
PBr6
Golden Acrylic
Mars Yellow
PY42
Old Holland Classic Oil

Bronze Yellow
PY42/PBr7
Liquitex Acrylic
Bronze Yellow
PY42/PBr7
Daler-Rowney Cryla Acrylic
Yellow Oxide
PY42
Liquitex Acrylic
Yellow Oxide
PY42
Golden Acrylic

Raw Sienna
PY43
Talens Van Gogh Oil
Raw Sienna
PY42
Lukas Studio Oil
Raw Sienna
PY42/PR101 Trans/PBk9
Daler-Rowney Cryla Acrylic
Raw Sienna
PY42
Rowney Egg Tempera

Earths – Red Ochre to Chinese Orange

Colour Index

Red Ochre
PR102
Old Holland Classic Oil
Red Ochre
PR101
Maimeri Puro Oil
Brown Ochre Light
PBr7
Old Holland Classic Oil
Brown Ochre
PR101/PBk11
Talens Rembrandt Oil

Deep Ochre
PR102
Old Holland Classic Oil
Terra Rosa
PR101
Winsor & Newton Artists' Oil
Mars Orange
PY42
Maimeri Artisti Oil
Pouzzoles Red
PR101/PY154
Sennelier Artists' Oil

Quinacridone Gold
PO49
Winsor & Newton Finity Acrylic
Quinacridone Gold
PO48/PO49
Golden Acrylic
ACRA© Gold
PO48/PY83
Liquitex Acrylic
Chinese Orange
PR83/PY13
Sennelier Artists' Oil

Ochres

Ochres/Mars

Quinacridones

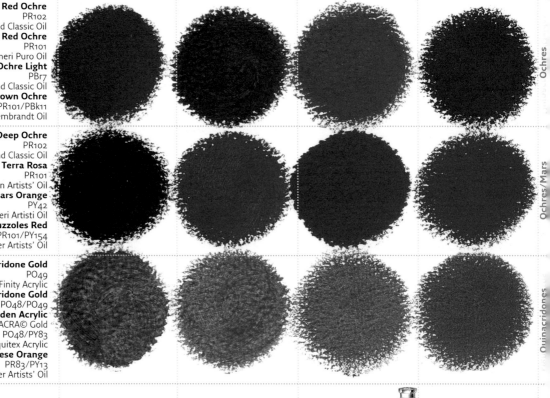

112

Earths – Burnt Orange to Red Earth

Quinacridones/Oxides

Quinacridone Burnt Orange
PO206
Winsor & Newton Finity Acrylic
Transparent Oxide Orange
PY42/PR101
Talens Rembrandt Acrylic
Transparent Oxide Red
PR101
Talens Rembrandt Acrylic
Translucent Red Oxide
PR101
Schmincke Mussini Oil

Transparent

Transparent Brown
PBr25
Tri-Art Acrylic
Italian Brown Pink Lake
PR101/PY83
Old Holland Classic Oil
Transparent Mars Brown
PR101
Maimeri Puro Oil
Transparent Oxide Red Lake
PR101
Old Holland Classic Oil

Light reds/Red earths

Light Red Oxide
PR101
Talens Van Gogh Oil
Red Oxide
PR101
Liquitex Acrylic
Red Oxide
PR101
Golden Acrylic
Red Earth
PR5/PR8/PR101
Daler-Rowney Designers' Gouache

Colour Index

Earths – English Red to Caput Mortuum

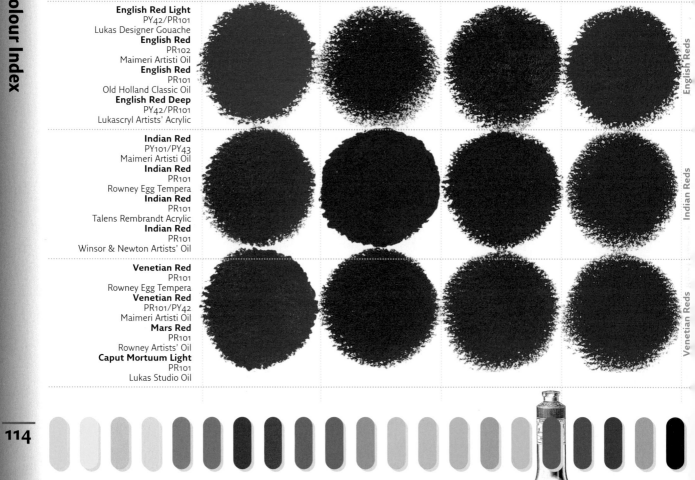

English Red Light
PY42/PR101
Lukas Designer Gouache
English Red
PR102
Maimeri Artisti Oil
English Red
PR101
Old Holland Classic Oil
English Red Deep
PY42/PR101
Lukascryl Artists' Acrylic

English Reds

Indian Red
PY101/PY43
Maimeri Artisti Oil
Indian Red
PR101
Rowney Egg Tempera
Indian Red
PR101
Talens Rembrandt Acrylic
Indian Red
PR101
Winsor & Newton Artists' Oil

Indian Reds

Venetian Red
PR101
Rowney Egg Tempera
Venetian Red
PR101/PY42
Maimeri Artisti Oil
Mars Red
PR101
Rowney Artists' Oil
Caput Mortuum Light
PR101
Lukas Studio Oil

Venetian Reds

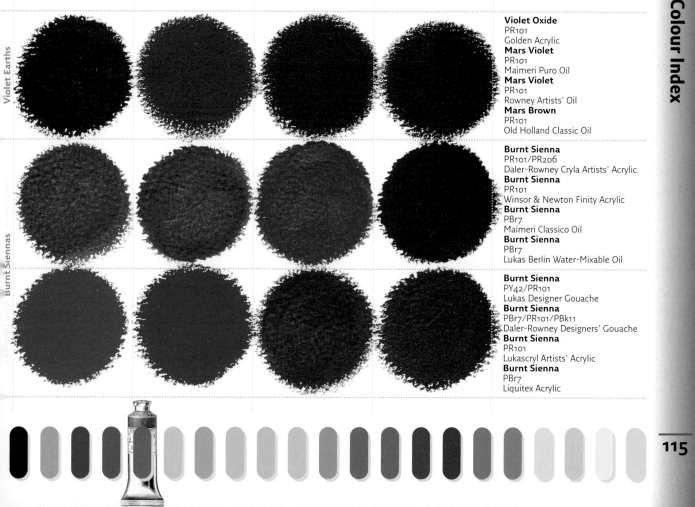

Violet Earths

Burnt Siennas

Violet Oxide
PR101
Golden Acrylic
Mars Violet
PR101
Maimeri Puro Oil
Mars Violet
PR101
Rowney Artists' Oil
Mars Brown
PR101
Old Holland Classic Oil

Burnt Sienna
PR101/PR206
Daler-Rowney Cryla Artists' Acrylic
Burnt Sienna
PR101
Winsor & Newton Finity Acrylic
Burnt Sienna
PBr7
Maimeri Classico Oil
Burnt Sienna
PBr7
Lukas Berlin Water-Mixable Oil

Burnt Sienna
PY42/PR101
Lukas Designer Gouache
Burnt Sienna
PBr7/PR101/PBk11
Daler-Rowney Designers' Gouache
Burnt Sienna
PR101
Lukascryl Artists' Acrylic
Burnt Sienna
PBr7
Liquitex Acrylic

Earths – Brown Madder to Vandyke Brown

☞ **Note**
Dark pigments are also shown with a white tint detail to bring out the true character of the colours.

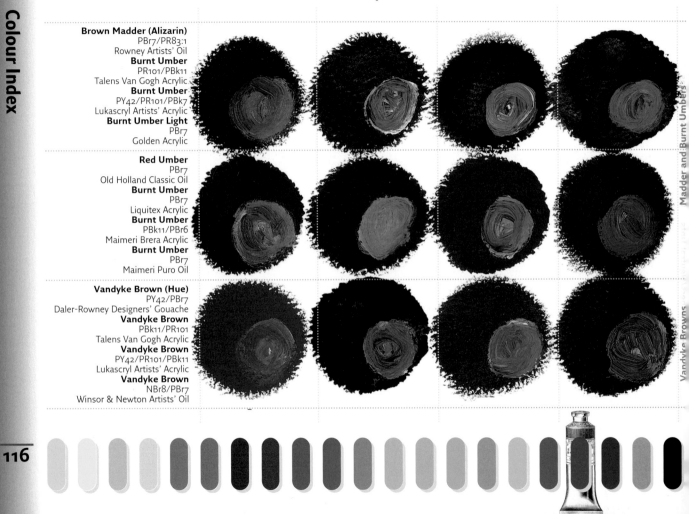

Brown Madder (Alizarin)
PBr7/PR83:1
Rowney Artists' Oil
Burnt Umber
PR101/PBk11
Talens Van Gogh Acrylic
Burnt Umber
PY42/PR101/PBk7
Lukascryl Artists' Acrylic
Burnt Umber Light
PBr7
Golden Acrylic

Red Umber
PBr7
Old Holland Classic Oil
Burnt Umber
PBr7
Liquitex Acrylic
Burnt Umber
PBk11/PBr6
Maimeri Brera Acrylic
Burnt Umber
PBr7
Maimeri Puro Oil

Vandyke Brown (Hue)
PY42/PBr7
Daler-Rowney Designers' Gouache
Vandyke Brown
PBk11/PR101
Talens Van Gogh Acrylic
Vandyke Brown
PY42/PR101/PBk11
Lukascryl Artists' Acrylic
Vandyke Brown
NBr8/PBr7
Winsor & Newton Artists' Oil

Madder and Burnt Umbers

Vandyke Browns

Earths – Cassel Earth to Neutral Tint

Cassel Earth
PR176/PY74/PBk7
Lukas Studio Oil
Cassel Earth
PBr7/PBk7
Maimeri Artisti Oil
Bitumen
Bk6
Maimeri Artisti Oil
Sepia
PR101/PG7
Tri-Art Acrylic

Sepia Warm Extra
PBk7/PR102/PBr7
Old Holland Classic Oil
Sepia
PY42/PR101/PBk11
Talens Rembrandt Oil
Raw Umber
PY42/PBr7
Daler-Rowney Designers' Gouache
Raw Umber
PY42/PR101/PBk11
Lukascryl Artists' Acrylic

Raw Umber
PY42/PBk11
Talens Van Gogh Acrylic
Raw Umber
PBr7/PG17
Maimeri Artisti Oil
Raw Umber
PBr7
Winsor & Newton Artists' Oil
Neutral Tint
PB15/PV19B/PBr7
Old Holland Classic Oil

Blacks & Greys – Vine Black to Payne's Grey

Colour Index

Vine Black
PBk7
Lukas Sorte 1 Oil
Vine Black
in Titanium White tint

Mars Black
PBk11
Maimeri Puro Oil
Mars Black
in Titanium White tint

Ivory Black
PBk9
Talens Van Gogh Oil
Ivory Black
inTitanium White tint

Lamp Black
PBk7
Rowney Artists' Oil
Lamp Black
in Titanium White tint

Payne's Grey
PBk11/PB15/PV19
Talens Van Gogh Oil
Payne's Grey
in Titanium White tint

Payne's Grey
PB29/PBk7
Golden Acrylic
Payne's Grey
in Titanium White tint

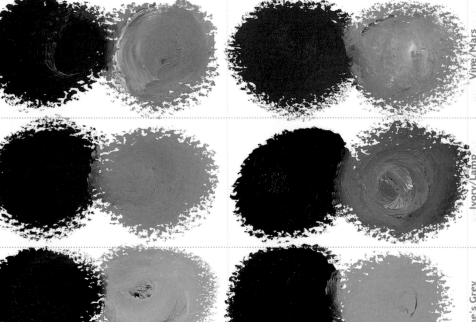

Vine/Mars Ivory/Lamp Payne's Grey

Blacks & Greys – Blue Black to Davy's Grey

Blue Black
PB29
Winsor & Newton Artists' Oil
Blue Black
in Titanium White tint

Graphite Grey
PBk10
Tri-Art Acrylic
Graphite Grey
in Titanium White tint

Atrament Black
PBk31
Schmincke Mussini Oil
Atrament Black
in Titanium White tint

Davy's Grey
PG23/PW4/PBk9/PBr7
Old Holland Classic Oil
Davy's Grey
in Titanium White tint

Davy's Grey
PBk19/PY42/PBk7
Winsor & Newton Artists' Oil
Davy's Grey
in Titanium White tint

Davy's Grey
PBk19/PY42/
Winsor & Newton Finity Acrylic
Davy's Grey
in Titanium White tint

Greys – Titan to Warm Grey

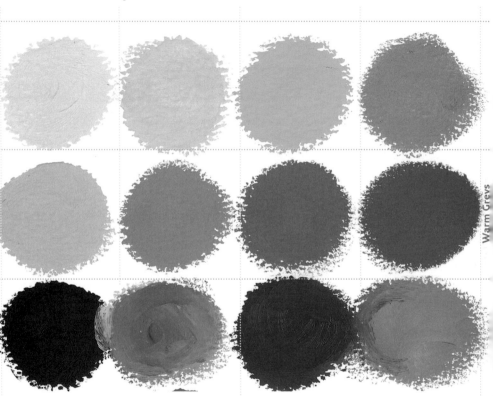

Colour Index

Warm Greys

Titan Buff
PW6
Golden Acrylic
Unbleached Titanium
PBr7/PY42/PW6
Liquitex Acrylic
Buff Titanium
PY42/PW6
Winsor & Newton Finity Acrylic
Old Holland Warm Grey Light
PW4/PW6/PBk7/PBr7
Old Holland Classic Oil

Warm Grey 1
PBr7/PBk9/PW6
Daler-Rowney Gouache
Warm Grey 2
PBr7/PBk9/PW6
Daler-Rowney Gouache
Warm Grey 3
PBr7/PBk9/PW6
Daler-Rowney Gouache
Grey 1 (Warm Grey)
PW5/PBk7/PY42
Lukas Sorte 1 Oil

Scheveningen Warm Grey
PW4/PW6/PBk9/PBr7
Old Holland Classic Oil
*Scheveningen Warm Grey
in Titanium White tint*

Warm Grey
PW4/PR101/PBr9
Talens Rembrandt Oil
*Warm Grey
in Titanium White tint*

120

Greys – Middle Grey to Cool Grey

Middle/Neutral/Cool

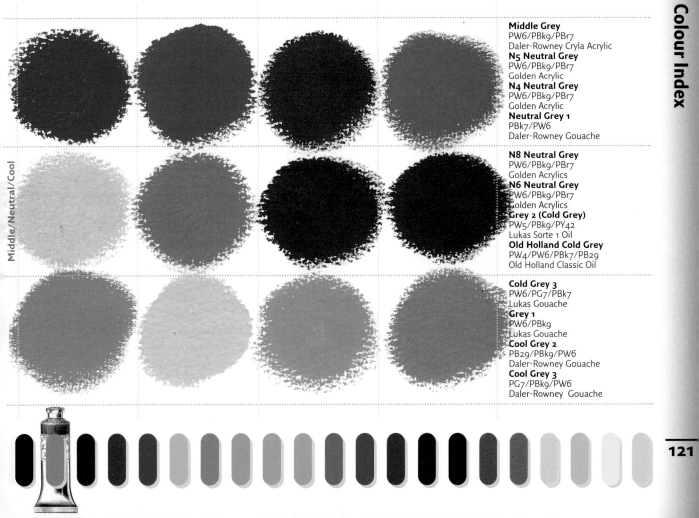

Middle Grey
PW6/PBk9/PBr7
Daler-Rowney Cryla Acrylic
N5 Neutral Grey
PW6/PBk9/PBr7
Golden Acrylic
N4 Neutral Grey
PW6/PBk9/PBr7
Golden Acrylic
Neutral Grey 1
PBk7/PW6
Daler-Rowney Gouache

N8 Neutral Grey
PW6/PBk9/PBr7
Golden Acrylics
N6 Neutral Grey
PW6/PBk9/PBr7
Golden Acrylics
Grey 2 (Cold Grey)
PW5/PBk9/PY42
Lukas Sorte 1 Oil
Old Holland Cold Grey
PW4/PW6/PBk7/PB29
Old Holland Classic Oil

Cold Grey 3
PW6/PG7/PBk7
Lukas Gouache
Grey 1
PW6/PBk9
Lukas Gouache
Cool Grey 2
PB29/PBk9/PW6
Daler-Rowney Gouache
Cool Grey 3
PG7/PBk9/PW6
Daler-Rowney Gouache

Whites – Zinc to Pearl

Zinc White
PW6
Winsor & Newton Artists' Oil
Underpainting White
PW6/PW4
Winsor & Newton Artists' Oil
Warm White
PW6
Tri-Art Acrylic
Iridescent White
Mica-coated titanium dioxide
Liquitex Acrylic
Flake White
PW1/PW4
Old Holland Classic Oil
Mixed White
PW6/PW4
Talens Van Gogh Oil
Opaque White
PW4
Lukas Studio Oil
Iridescent Pearl
Mica-coated titanium dioxide
Tri-Art Acrylic
Cremnitz White
PW1
Old Holland Classic Oil
Titanium White
PW6/PW4
Rowney Artists' Oil
Mixing White
PW6
Rowney Artists' Oil
Iridescent Pearl (Coarse)
Mica-coated titanium dioxide
Golden Acrylic

Materials – Guide to main suppliers

There are hundreds of art materials manufacturers, ranging from small specialists who produce traditional pigments using time-honoured methods, to well-known brands that are household names recognized throughout the world. Many European and North American manufacturers have assisted with images, materials and information in the making of this book and the following have been particularly generous in supplying samples.

Daler-Rowney Ltd
Bracknell, Berkshire RG12 8ST, UK
Telephone: 01344 461000
Fax: 01344 486511
www.daler-rowney.com

Winsor & Newton
Whitefriars Avenue
Harrow, Middlesex
HA3 5RH, UK
Telephone: 020 8427 4343
Fax: 020 8863 7171
www.winsornewton.com

Royal Talens
PO Box 4, 7300 AA Apeldoorn
The Netherlands
Telephone: (+31) 55-52.74.700
Fax: (+31) 55-52.15.286
www.talens.com

Golden Artist Colors Inc.
188 Bell Road,
New Berlin, NY 13411-9527, USA
Telephone: (+1) 800-959-6543
Fax: (+1) 607-847-6767
www.goldenpaints.com

Maimeri S.p.a.
Via Gianni Maimeri 1
20060 Bettolino di Mediglia
Milan, Italy
Telephone: (+39) (02) 906981
Fax: (+39) (02) 90698999
www.maimeri.it

Lukas
Dr Fr. Schoenfeld GmbH & Co
Postfach 10 47 41
40038 Düsseldorf, Germany
Telephone: (+49) 0-211-7813-0
Fax: (+49) 0-211-7813-24
www.lukas-germany.de

H. Schmincke & Co. - GmbH & Co. KG
Otto Hahn Strasse 2
D-40699 Erkrath, Germany
Telephone (+49) 0-211-2509-0
Fax: (+49) 0-211-2509-461
www.schmincke.de

Old Holland
Nijendal 36
3972 KC Driebergen
The Netherlands
www.oldholland.com

Liquitex UK
ColArt Fine Art & Graphics Ltd
Whitefriars Avenue, Harrow
Middlesex HA3 5RH, UK
Telephone: 020 8427 4343
www.liquitex.com

Sennelier
Max Sauer S.A.
2 Rue Lamarck BP204
22002 Saint-Brieuc cedex France
Telephone: (+33) 02 96 68 20 00
Fax: (+33) 02 96 61 77 19
www.max-sauer.com

Tri-Art
Woolfitt's Art Enterprises Inc.
1153 Queen Street West
Toronto, Ontario M6J 1J4, Canada
Telephone: (+1) 416 536 7878
Fax: (+1) 416 536 4322
www.woolfitts.com

Global Arts
(UK Importers of Sennelier, Golden).
Unit 13-16
Mills Way Centre
Amesbury, Wiltshire, SP4 7RX
Telephone: 01980 625625
www.globalartsupplies.co.uk

Pigment standards

Colours are not the same; just as loaves of white bread from different bakers will differ, so will artists' colours from different manufacturers. The formulation or recipe of the colour, in conjunction with the manufacturing method and choice of raw materials, produces many variations between colours with the same name from different suppliers.

There are a number of universal systems and standards that help artists to identify and build knowledge in key areas of concern. Most importantly artists are interested in the specific characteristics of pigments so that they may use them to achieve their own creative ends. Next, they need information regarding the permanence of pigments. The characteristics of a colour – such as granulation, staining, bleeding, transparency or opacity, colour bias, and drying rate – are to be found in both reference books and manufacturers' colour charts. Permanence ratings are also provided by manufacturers.

There are no set standards for pigment characteristics. After all it is the diversity and individuality of each material that painters want to exploit. Generally, good quality products are offered by the whole art materials industry and for most artists the literature and information supplied is sufficient for their needs. However, you may want to know more about the media you are using and to do this pigments need to be clearly identified.

The Colour Index International
Since the development of modern organic pigments, pigment names are no longer sufficient to identify the actual pigment being used. For instance, there are dozens of naphthol reds with varying characteristics and different levels of lightfastness. The Colour Index International identifies each pigment ensuring artists know what they are using. Most artists' materials manufacturers publish the pigment content of their colours.

ASTM
The ASTM abbreviation stands for the American Society for Testing and Materials. (The UK equivalent is the British Standards Institute.) The ASTM has set standards for the performance of art materials and this includes lightfastness. It is the lightfastness ratings with which artists are most familiar. Pigments are tested in reduction with white in both artificially accelerated conditions and desert sunshine. Ratings I and II are recommended as 'Permanent for artists' use'. Art materials manufacturers rate their colours in a similar way and where no ASTM rating is given this usually means that the pigment is new and has not yet been tested by ASTM. In these cases the manufacturer's rating will be available.

Advancing colours
Colours that appear to move towards the front of the picture plane. These tend to be the 'warm' colours such as reds, yellows and oranges. (See also Receding colours)

Alizarin
One of the constituent dyes of the madder root, produced synthetically from the 1860s.

Artists' quality colours
Paints made with best quality ingredients. They contain maximum purest pigments and binders.

Azo
Descriptive word pertaining to synthetic organic pigments, short for 'diazotized amines'.

Body colour
Opaque water-based paint, particularly gouache, also known as designers' colour. The term 'body' can also refer to the density of a colour.

Broken colour
Applying colour so that previous layers of other colours show through to maximum optical effect.

Chroma
A term used to designate the purity of a colour. A colour with high chroma contains little or no grey. (See also Saturation)

Colour terminology

CMYK
Acronym for cyan, magenta, yellow and black, the four colours used in the printing process. (See also Four-colour process)

Colour temperature
Colours may be described as 'warm' or 'cool'. Colours within a hue may also be described as warm or cool in relation to each other. (See also Warm colours and Cool colours)

Colour
The visual sensation and attributes of distinguishable wavelengths of refracted or reflected light.

Colour wheel
The arrangement of primary and secondary colours into a circle in the order of the spectrum. Intermediary colours may be added to enlarge the circle. Used as a basic device to explain colour theory.

Complementary colours
Colours that are opposite each other on the colour wheel. Red is the complementary of green, yellow of violet, and blue of orange. Similarly, on the enlarged colour wheel, red-orange is the complementary of blue-green, yellow-orange of blue-violet, and yellow-green of red-violet.

Cool colours
Colours in the green/blue/violet sector of the colour wheel are generally described as cool.

Found colours
Colours that may be obtained from non-paint sources such as natural materials, liquids and foodstuffs.

Four-colour process
The printing process that uses three process colours – cyan, magenta and yellow – and black to produce a full-colour effect. (See also CMYK)

Ground colour
A colour applied to a prepared support to give a more sympathetic background to a painting rather than brilliant white.

Harmonious colours
Colours that are near each other on the colour wheel, generally involving no more than two primary colours.

Dead colour
Sometimes used to refer to the underpainted colours in a painting.

Hue
The general name for a colour, such as red or green. Hue may also be used to describe the comparative character of a colour; for instance, Vermilion and Cadmium Red may be said to be similar in hue. Modern colour manufacturers also use the term to denote that a synthetic pigment has been used to replicate the colour of a traditional one.

Intensity
The brightness and strength of a colour, also called saturation. Intensity also links to purity of colour.

Lake
The pigment colour produced by dyeing a white inorganic mineral powder such as gypsum or chalk with organic colouring matter through the use of a mordant.

Local colour
The actual colour of an object with no added effects of light or shade or any reflected colour.

Luminosity
The quality of reflecting light, particularly in watercolour, where areas of white paper show through the layers of paint.

Mars colours
Applied to colours with artificial iron oxide as their source. Mars was the alchemical name for iron.

Monochrome
An image made using different tones of either black and white or a single colour.

Permanence
The degree to which a pigment is lightfast or liable to fade on exposure to light. Art materials' manufacturers supply details as to the permanence of individual colours in their product ranges.

Pigment
The colouring agent in drawing and painting media. Originally from natural plant and mineral sources, most pigments are now synthetic. Pigment also refers to pure colour in powder form.

Primary colours
The three primary colours – red, yellow and blue – are so called because they cannot be mixed from other colours. In theory, however, all other colours can be mixed from primaries. All three primaries mixed together produce 'black'.

Process colours
The colours used in the four-colour printing process. (See also CMYK)

Receding colours
Colours that appear to move into the distance within the picture plane. These tend to be the 'cool' colours, particularly blues. (See also Advancing colours)

Reflected colour
The light reflected from a coloured surface onto another object, so modifying the object's own local colour. (See also Local colour)

Colour terminology

Saturation
The degree of vividness and purity of a colour. A light colour or tint may be regarded as of low saturation, while pure colour is termed fully saturated or of high saturation. (See also Intensity)

Secondary colours
Colours obtained by mixing two primary colours. Orange is produced from red and yellow, green from yellow and blue, and violet from blue and red.

Shade
A colour that has been darkened by the addition of black.

Spectrum
The arrangement of colours produced when white light passes through a prism. Seven separate colours are distinguished – red, orange, yellow, green, blue, indigo and violet.

Split complementaries
These are colours that are adjacent to the true complementary of a colour. For instance, the split complementaries of blue are red-orange and yellow-orange.

Staining colours
A term that refers particularly to watercolours. Some colours are made from very finely ground particles of pigment and may not be completely 'lifted out' from the paper if required.

Tertiary colours
Colours produced by mixing equal proportions of a primary colour with its adjacent secondary colour. For instance, yellow mixed with green gives yellow-green.

Tint
A colour that has been lightened by the addition of white.

Tone
The lightness or darkness of an element in a drawing or painting, irrespective of its local colour. Also called value. The term tonal value is also used to describe the relation of one tone to another.

Top tone
The obvious hue of a colour, such as red or blue. (See also Undertone)

Transparency
The degree to which light can pass through a colour. Watercolour is a transparent medium, but thinned glazes of oils and acrylics may also allow transparency.

Undertone
The underlying tone of a colour, which may veer towards another hue. For instance, a blue may be a reddish or yellowish blue. (See also Top tone)

Warm colours
Colours in the red/orange/yellow sector of the colour wheel are generally described as warm.

126

Index

Page numbers in bold refer to captions.

advancing & receding colours **31**, 124, 125
Alizarin Crimson 27, **28**, 29, **29**, 31, 62, 92
animal sources 39, 60
arsenic compounds 25, 37, 47, **50**
arylamides 42, 43
arylides 9
asphaltum (bitumen) **61**, **62**, 71, 117
ASTM 124
Aureolin 41, 85
azo colours 34-5, 41, 83, 88, 124
azurite 13, 15, 46

Benzimidazolone Orange 34-5, 88
bistre 62
bitumen (asphaltum) **61**, **62**, 71, 117
blacks **7**, 61, **62**, 64-71, 118-19
 cave paintings **8**, 37, **44**, **57**
blues 12-19, 98-103
Bone Black 65, 67
brown & red earths 56-63, 112-17
Brown Madder 62, 116
Brown Ochre 56, **57**, 112
Burnt Sienna 56, 63, 115
Burnt Umber 56, 62, 63, **77**, 116
Cadmium colours 8, 31
 Cadmium Green 50, **51**, 106
 Cadmium Orange **33**, 34, 88
 Cadmium Red 27, 31, 89, 90, 91, 92

Cadmium Yellow 31, **37**, **40**, 42, 82, 83, 84
Caput Mortuum 23, **23**, 25, 61, 114
carbon black **8**, 37, **44**, 65, 67, 70, 73
Cardinal Red **25**
Cardinals' Purple **25**
carmine 29, 93
cave paintings **8**, 37, **44**, 57
Cerulean Blue 16, 17, 18, **19**, 101
charcoal 71, 73
Chinese White **76**
Chrome Lemon 40
Chrome Orange **33**, 34, 88
Chrome Yellow 40, **42**, 49, 50, 85
Chromium Oxide Green 49, 50, **51**, **52**, **53**, 108
chrysocolla 47
cinnabar 8, 26, **26**, **51**, 107
CMYK 7, 125
cobalts 8, 15, **16**, 17, 96
 Aureolin 41, 85
 Cobalt Blue 15, 16, **16**, 17, **19**, 100, 101
 Cobalt Green 50, **51**, **53**, 105
 Cobalt Turquoise 21, **21**, 104
cochineal 29
Colour Index International 124
complementary colours 22, 24, **27**, 53, 72, 125, 126
Cool Greys **73**, 74, 121
copper compounds 13, **16**, 46, **49**, **50**
cow urine 39

Index

Cremnitz White 76, 122
crimson 29
 see also Alizarin Crimson
cuttlefish 60
cyan **7**, 12, **18**, **19**, 103

Davy's Grey 73, **74**, 119
Delftware 15
Dioxazine Violet 22, **23**, **71**, **77**, 97
Dragon's Blood **26**
Dutch White **75**

earth pigment categories 8, **8**, 56-7,
108-17
Emerald Green 50, **50**, **51**, **53**, 104, 105
English Red 114

Flake White 76, 122
four-colour process **7**, **18**, 125
French Ultramarine 16, 17, 99
frit 13, 15

Gamboge 38, 43, **51**, 86
giallorino **38**
gold 38
Golden Yellows 43
Graphite Grey 73, **74**, 119
Green Earth 50, 54-5, 56, 109
greens 46-55, 104-9
greys 70, 72-4, 118-21
 see also Payne's Grey

grisaille 72
guazzo 73

Hansa yellows 9, 41, 83
Helios & Helio colours 37, 39, 88, 90,
99, 106
hematite 57, 58
Hooker's Green 50, **51**, **53**, 108

IKB **19**
Indanthrene Blue 16, **16**, 18, 98
Indian Red 25, 56, **57**, 114
Indian Yellow 39, 43, 85, 86
Indigo 13, 14, **16**, 18, **77**, 98
insects 25, **25**, 29
International Klein Blue **19**
Iridescent White 77, 122
iron compounds **16**, 17, 23, 54
 iron oxides 25, 37, 43, 44-5, 56-63,
66, 73, 125
Ivory Black 66, 67, 68-9, 70, 118
Iznik tiles 15

Judas hair **27**

Kassel Earth 60
kermes 25, **25**, 29

lakes 14, 25, **29**, **30**, 34, **39**, 49, 125
Lamp Black **8**, 67, 68-9, 70, 118
lapis lazuli 12, 14, **15**, 17

lead compounds 25, 37, 40, 75, 76
Lemon Yellow 40, 43, 70, 82
Leyden Blue 15
lightfast pigments 9, **9**, 125
limonite 37, 58

madders 28, **28**, **29**, 62, 93, 116
magentas **7**, **18**, 22, **30**, **31**, 95
malachite 13, 46
Manganese Blue **16**, 18, 102
Mars colours 8, 61, 112, 125
 Mars Black 61, 66, **66**, **67**, 68-9, 118
 Mars Brown **57**, 61, 113, 115
 Mars Red 25, 58, 61, 114
 Mars Violet **22**, 23, 25, 61, 115
 Mars Yellow 37, 61, 111
massicot 37
Mauve **16**, 22, 97
mixing colours **18**, 20, **21**, **34**, 52, 64, 65,
72, 76-7, 126
Mummy Brown **61**

name lists **13**, **27**, **32**, **37**, **39**, **48**, **57**, **65**
Naphthol Red 30, 89, 91
Naples Yellow 41, **41**, 42, 81, 87
Neutral Greys 73, **74**, 121
Neutral Tint **16**, 117

Olive Green 50, **51**, **52**, 109
oranges 32-5, 88, 89
orpiment **37**, **38**, 40

Payne's Grey **16**, 66, **67**, 68-9, 71, 73,
74, **77**, 118
Perinone Orange 34
perylenes 8, 9, 30, 91
phthalocyanines & Phthalo colours 8,
16, 18, 20, 71
 Phthalo Blue 16, 18, **19**, 99
 Phthalo Green **47**, **50**, **51**, **53**, **77**, 106
 Phthalo Turquoise **21**, **71**, 103, 105
pigment categories 8-9
pigment standards 124
'pinks' **39**, 86
plant sources 13, 14, 25, 28, 38, 39, 49,
62, 67, 71
Pozzuoli Earth 62
prehistoric primaries **8**, 37, **44**, 57
Primary Blue **18**, **19**, 102
process colours **7**, **18**, 82, 95, 103, 125
Prussian Blue 16, 17, **17**, 18, 50, **51**,
77, 98
purples 22, **25**, 93, 96
Pyrrole colours 8, 9, 30, 35, 88, 89, 90

quinacridones 8, 22, **23**, **30**, **33**, 90, 94,
96, 112, 113

Raw Sienna 56, 63, 111
Raw Umber 56, 62, 63, **71**, 117
realgar 25, 32, **32**
red & brown earths 56-63, 112-17
Red Ochre **8**, 37, **44**, 56, 57, **57**, 61, 112

Index
Page numbers in bold refer to captions.

reds 24-31, 89-96
resists **77**
Rose Madder 8, 27, 28, 93
rose pinks 94

saffron 38, 107
Sap Green 49, **49**, 50, **51**, **53**, 108
scales, grey & tone 70
Scheele's Green 47
Sepia 60, **77**, 117
shading 65, 70, 126
siennas 8, 56, **57**, 63, 111, 115
Sinopia 25, 58
Smalt 15, 17
Spanish Brown 56, **57**
stack process **75**

Terre Verte 50, 54-5, 56, 109
Thénard's Blue 17
tiles 15
tints **53**, **60**, 65, 68-9, 70, 71, **77**, 118-19, 126
Titanium White 8, **60**, 68-9, 76, 77, 118-19, 122
tone scale 70
turmeric 38
turquoises 20-1, **21**, 103, 104, 105

Ultramarine 8, 12, 13, 14, **14**, **15**, 17, **19**, 99, 100
 synthetic 17, **19**, **67**, **68**, 99, 100

umbers 8, 55, **57**, 60, 109, 116
 see also Burnt Umber; Raw Umber
Underpainting White 77, 122
undertones 68-9, 126

Vandyke Brown **57**, 60, **77**, 116
variables 9, **19**, 27, 66, 70, 80
vegetable greens 49
Veneda 72
Venetian Red 25, 56, **57**, 62, 114
verdigris **49**
Vermilion 26, 89, 92
Vine Black 66, 67, 68-9, 118
violets 22-3, 61, 96-7, 115
Viridian Green **47**, 50, **51**, **52**, **53**, 55, 71, **71**, 77, 105

Warm Greys **73**, 74, 120
whites **7**, **8**, 37, **56**, 75-7, 122
 see also tints
Winsor colours 18, 27, 35, 41, 89, 90, 98, 104, 106
woad 13, 14

Yellow Ochre **8**, 37, 43, 44-5, 56, 57, 61, 86, 110
yellows **7**, 9, **18**, 36-45, 81-7

Zinc White 76, **76**, 122

Acknowledgements

The Collins *Artist's Little Book of Colour* is based on material from Collins *Artist's Colour Manual* © The copyright in the images reproduced in the *Artist's Little Book of Colour* remains with the individual artists/successors, photographers, art materials manufacturers and publishers, and is reproduced here by prior arrangement and/or kind permission. In case of any errors or omissions please contact the publishers for rectification in subsequent editions. All the colour samples and swatches were painted specifically for this book, with the exception of the diagonal colour chart samples used on pages 8, 12, 20, 24, 32, 36, 46, 56, 72, which were kindly supplied by H. Schmincke & Co. The title page image on page 1 was kindly supplied by Great Art (Gerstaecker UK Ltd) on behalf of H. Schmincke & Co. The antique product engravings are from G. Rowney & Co 1913 Wholesale Catalogue and are reproduced by kind permission of Daler-Rowney.

The following generously donated images, materials and equipment for review and sampling throughout this book.

Daler-Rowney
Global Arts
Golden
Great Art (Gerstaecker UK Ltd)
Liquitex
Lukas
Maimeri
Old Holland
Royal Talens
Schmincke
Sennelier
Tri-Art
Winsor & Newton